William Sidney Mount

Works in the Collection of The Museums at Stony Brook

Written by
David Cassedy & Gail Shrott

Edited by
Janice Gray Armstrong

The Museums at Stony Brook
Stony Brook, New York

Front Cover:

Farmers Nooning 1836
Oil on canvas
51.5 × 61.5 (20¼ × 24¼)
Inscription: (lower left) *Wm. S. Mount 1836*
Gift of Frederick Sturges, Jr., 1954

Back Cover:

Study for Farmers Nooning 1836
Oil on canvas
8.5 × 11.0 (4⅜ × 5⅜)
Bequest of Ward Melville, 1977

Signature, William Sidney Mount

The research for this book was made possible, in part, with public funds from the New York State Council on the Arts.

Funds from the National Endowment for the Arts, a federal agency, the Kress Foundation and other private donors have made the production of this book possible.

This book is made possible, in part, with funds from The Museums at Stony Brook Publications Fund which was established with the support and encouragement of Mrs. F. Henry Berlin. A portion of the sales income from this book will augment that revolving fund in order to finance future productions of books about The Museums collections. Contributions to the Publications Fund will be tax deductible and gratefully acknowledged.

Susan Stitt, *Director*
Martha V. Pike, *Assistant Director for Curatorial Affairs*

David Cassedy, *Curator, Art Collection and Archives*
Gail Shrott, *Intern*
Janice Gray Armstrong, *Registrar/Researcher*

Design by Joseph del Gaudio Design Group Inc.
Photography by Quesada/Burke, New York, for all works in The Museums at Stony Brook's collection, except where otherwise noted.
Printing by Colorcraft Lithographers, Inc.
Publishing by The Museums at Stony Brook
 1208 Route 25A
 Stony Brook, New York 11790

Copyright © 1983 The Museums at Stony Brook

ISBN 0-943924-06-5

Library of Congress Cataloging in Publication Data

Cassedy, David, 1950–
 William Sidney Mount : works in the collection of the Museums at Stony Brook.

 Bibliography: p.
 1. Mount, William Sidney, 1807–1868—Catalogs.
2. Museums at Stony Brook—Catalogs. I. Shrott, Gail, 1956– . II. Museums at Stony Brook. III. Title.
N6537.M677A4 1984 759.13 83-23646
ISBN 0-943924-06-5

225996

William Sidney Mount is the artist for all works of art and artifacts illustrated in this volume unless otherwise indicated.

Measurements are given in centimeters, height × width, followed by inches in parentheses.

In the interest of historical accuracy all original material is printed as it was written. Illegible, questionable or contextually suggested information is enclosed in brackets. Sic is not used.

Works cited in footnotes are fully identified only in the first reference to them. Subsequent references to them are written in a shortened form. The abbreviation "pp." is omitted preceding page numbers in footnotes.

Abbreviations

Diss.	dissertation
Exh. Cat.	exhibition catalog
Illus.	illustration(s)
M.A.T.	Master of Arts thesis
ms	manuscript
n.d.	no date, not dated
n. pag.	no pagination
p., pp.	page(s) (Abbreviation is omitted preceding page numbers in footnotes.)
Rev.	review
Rev. ed.	revised edition
TS	typescript

Contents

Portrait of William Sidney Mount 1848
Charles Loring Elliott
Oil on canvas
76.5 × 63.5 (30¼ × 25⅛)
Gift of the Estate of Ruth S. Kidder; Mrs. Mary Rackliffe; Miss
 Edith Douglass; Mr. Andrew E. Douglass; in memory of Mrs.
 Moses Douglass and Mrs. Scott (Ruth S.) Kidder, 1956

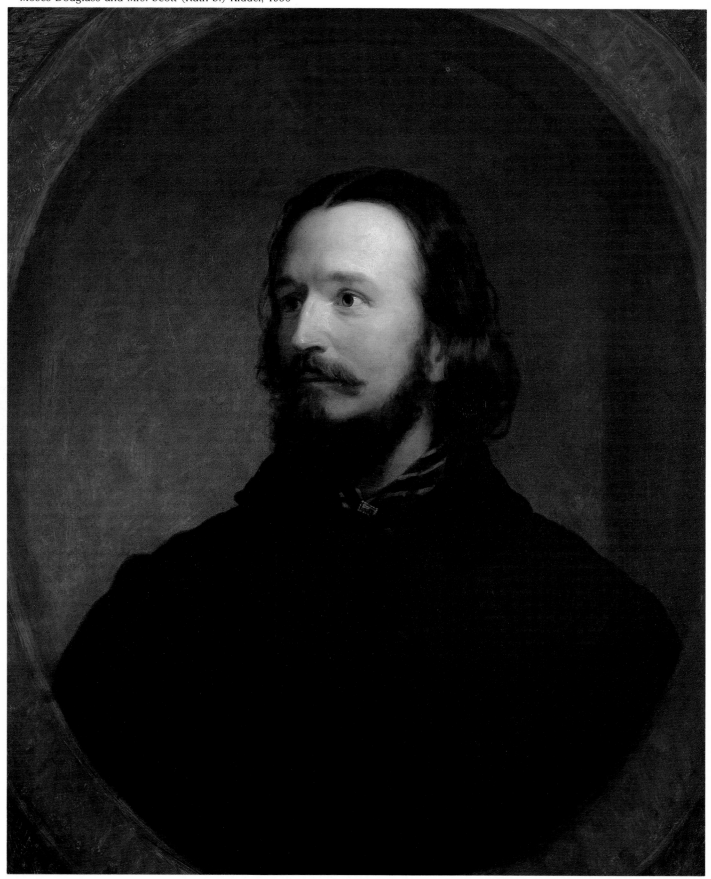

Foreword

My husband Ward Melville enjoyed history and architecture throughout his life. Known as a leader in the retail industry, he was respected as a philanthropist who cared deeply about people and the quality of their lives. He believed that people's lives were affected by the buildings, the landscape and the community in which they lived, and that their understanding of them, through historic artifacts and period architecture, gave them continuity with the past. A community enriched by its past would be strengthened for its future.

Mr. Melville's interest in local history was already well known when some friends told him about an auction of local historical material in 1942. I believe this was the sale of the estate of Clara Mount in Setauket. At this sale Mr. Melville bought a number of letters, diaries and sketches by William Sidney Mount because he was a local artist. In time Mr. Melville and Richard Gipson, who came to work for him, traced the location of many of Mount's paintings, some of which were unknown even when Cowdrey and Williams published their book on Mount in 1944, and started to buy them for what was then The Suffolk Museum. It is fortunate that we collected the paintings when we did, for it would not be possible to form such a collection today. As soon as the collection and the museum became known, others came forward to donate paintings, many of which had been in their families since they were acquired from the artist. As Mr. Melville was so interested in the preservation of Stony Brook's heritage, he even offered to protect and care for some Mount paintings held by local families whether they wished to donate them to the museum or not.

When the Mount paintings were being collected, there were people in the village of Stony Brook who had direct knowledge of the subjects in the paintings, as most of the people in Mount's genre paintings are little portraits which many of the older villagers were able to identify at the time. We were gratified to preserve, for example, not <u>only</u> California News, but also information for local history about the local residents who posed for that scene. Together, the painting and the information about its subjects make our knowledge and our records more accurate and more complete. Mr. Melville thought that Mount's paintings should stay in Stony Brook because Mount was a Stony Brook resident, and because his genre paintings show how people lived on Long Island in the nineteenth century. These paintings were never ours for they were collected and preserved for the public served by The Museums. Many students and scholars have made use of our unique material—Mount's letters, his preliminary sketches and his diaries. We have photocopied the diaries for use in several scholarly projects. We have been fortunate that other donors have increased our collection with their gifts since the 1940s. And many visitors to Stony Brook have enjoyed seeing the paintings by Mount, the Stony Brook resident and one of the first American painters of genre subjects. Because he never went abroad to study, as did many of his contemporaries, Mount was truly an American artist.

The Mount paintings did, however, become a treasured part of our lives, just as we wished them to be for others. When The Museums opened the Art Museum in 1974, Mr. Melville and I came, early the morning after the grand opening, to visit the Mount paintings in their new gallery. As we moved from painting to painting, from genre to portrait, we greeted old and dear friends. Though Mr. Melville's sight was fading, he knew every detail of these scenes and people as I read the labels and described the settings. His vision had been in earlier assembling the collection, and his reward was not only personal satisfaction but also the pleasure the collection provided for so many people.

This book enables The Museums to share the pleasures of this important collection with an ever-broadening audience of neighbors and friends across the country.

Dorothy B. Melville
Chairman of the Board of Trustees
The Museums at Stony Brook

Self Portrait 1832
Oil on canvas
60.8 × 50.5 (24 × 20)
Inscription: (on reverse) *Wm. S. Mount/1832*
Gift of Mr. and Mrs. Ward Melville, 1950
Photograph by Paul Kiehart

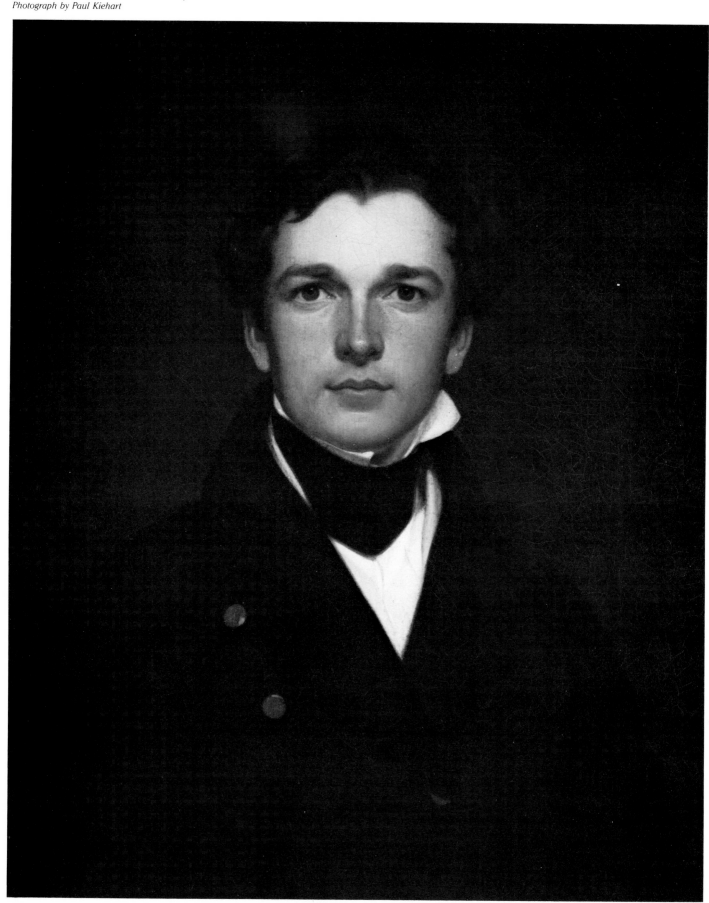

Introduction

An artist reflects his society through his individual and creative expression; in turn, an artist's reputation reflects his society's taste and values. Between 1868—when William Sidney Mount died—and 1944—when the first catalog of his work was published—American art and the way it was regarded changed considerably, as did American society. By the turn of the century, art like Mount's, that celebrated the particularity of the American landscape and character, was eclipsed by art that favored more cosmopolitan subjects and expression. At that time, though many of the popular artists painted subjects that were sometimes American in character or derivation, they painted them in the styles of international artistic movements. To these artists and their patrons Mount's paintings may have seemed insular and naïve, of interest to antiquarians perhaps, but not to connoisseurs and artists. Such attitudes were to change before William Sidney Mount regained his important position in the history of American art.

In 1868 William Sidney Mount died at the age of sixty-one, intestate and unmarried, at the Setauket home of his brother Robert Nelson Mount. In 1871 the administrators of his estate—his brother Robert Nelson Mount, his sister Ruth Mount Seabury and his nephew Thomas Shepard Mount—offered the contents of his studio for sale at auction in New York City. Half of the thirty-five paintings included in the auction were not sold, and were subsequently divided among the artist's next of kin. Many of his drawings and papers had been similarly dispersed the year before. Much of Mount's estate remained in his family or in the hands of other local residents well into the twentieth century. The Hawkins-Mount House in Stony Brook, the artist's home for many years, was occupied by members of his family until 1919. Fortunately the first owner of the house who was not a member of the family was William Sidney Mount's first biographer, Edward Payson Buffet (1873–1930).

Buffet studied engineering and the law, but apparently never practiced either profession. He worked as an editor and wrote and lectured on a wide variety of subjects—especially law, religion and technology—usually in their historical context. Buffet's interest in Mount seems to have begun when he moved into the Hawkins-Mount House and culminated in the serial publication of "William Sidney Mount, a Biography: The Story of Old-Time Life in Brookhaven North Told

through his Pictures" in the *Port Jefferson Times* in 1923 and 1924. The subtitle of Buffet's biography reveals the nature of his work: it is chatty, episodic, and as much concerned with Mount as a member of his family and his community as it is with Mount as a creator of paintings of lasting importance and artistic merit. When he wrote his biography Buffet made extensive use of such primary materials as Mount family letters, which he quoted at length. It is fortunate that he made use of such sources, many of which are otherwise unknown today, but it is frustrating that he did not always record the location of his sources. Similarly, Buffet photographed a number of Mount paintings and other historic artifacts in 1923 that have since been lost; no other record of them survives. Buffet also recorded oral history and local tradition, particularly concerning the people Mount used as models for his genre paintings. Little of this information can be substantiated today; nonetheless, Buffet and his informants were fairly close to Mount's generation and to the local residents who actually knew him.

Although he wrote about Mount's work and doubtless respected it, Edward Buffet revived interest in William Sidney Mount as an important figure in Long Island history. Beyond Long Island, scholars, museums and critics revived general appreciation and respect for Mount as a fine artist in the twenty years following the publication of Buffet's biography, a time when American art of earlier periods became a respectable field of study for art historians. Parallels between Mount's scenes of rural life and those of the "American Scene" painters of the 1930s—Grant Wood, John Steuart Curry, Thomas Hart Benton—may have encouraged critical and scholarly interest in Mount's work in the 1940s.

The Brooklyn Museum mounted an exhibition of 107 drawings and paintings by William Sidney Mount, the first comprehensive retrospective exhibition of his work, in 1942. In his foreword to the illustrated catalog of the exhibition, John I. H. Baur acknowledged, "the generous assistance of Miss Bartlett Cowdrey and Hermann W. Williams, Jr., whose authoritive catalogue of Mount's genre paintings will be published shortly. . . ."[1] Cowdrey and Williams' catalog was published by the Columbia University Press for The Metropolitan Museum of Art in 1944.

Between the Brooklyn exhibition in 1942 and the publication of Cowdrey and Williams' catalog in 1944, the collection to which the present volume is devoted

Sketch for Cider Making c. 1841
Pencil on paper
17.5 × 34.3 (6⅞ × 13½)
Museums Collection

Portrait of Shepard Alonzo Mount n.d.
Pencil on paper
23.5 × 19.7 (9¼ × 7¾)
Gift of Mrs. John Slade in memory of her aunt, Mrs. Sarah C. W.
Hoppin, 1957

William Sidney Mount Painting *Cider Making* 1841
Shepard Alonzo Mount
Pencil on paper
21.6 × 18.7 (8½ × 7⅜)
Museums Collection

Cider Making 1841
Oil on canvas
68.3 × 86.4 (27 × 34⅛)
Inscription: (lower left) *Wm. S. Mount. 1841*
The Metropolitan Museum of Art, Purchase, 1966 Charles Allen
 Munn Bequest

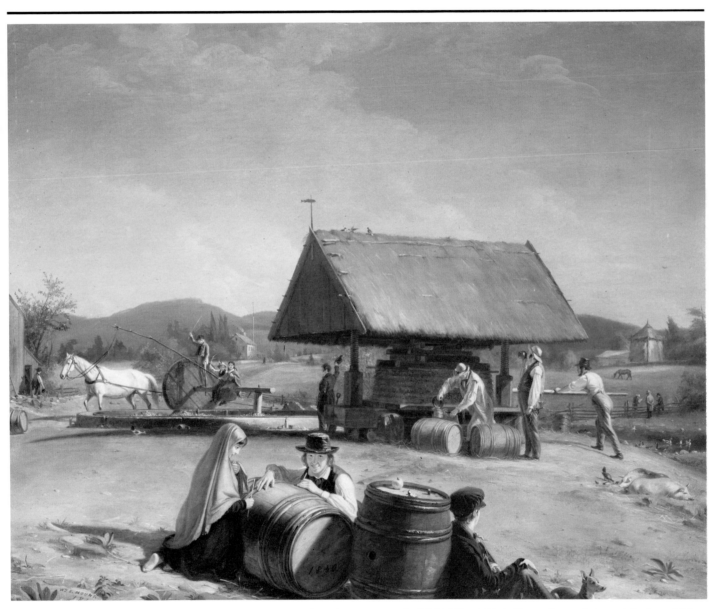

was begun. In January, 1940, Ward Melville, a local resident, proposed a plan for the revitalization of the village of Stony Brook. The implementation of his plan, which involved major construction of shopping facilities and landscaping of the picturesque harbor, was completed in 1941. It included a museum building for a previously assembled natural history collection which was granted a provisional charter by the University of the State of New York Education Department as The Suffolk Museum at Stony Brook in 1942, and granted an absolute charter under the same name in 1948.

In 1943 Ward Melville, whose interest in local history was well known, was informed of an auction sale of the estate of Clara Brewster Mount (1875–1943), the granddaughter of William Sidney Mount's brother Robert Nelson Mount (1806–1883). The following newspaper account of the sale documents the beginning of the Melville collection:

Carl J. Heyser, jr., acting for Ward Melville, of Stony Brook, purchased the following items, which Mr. Melville will place in the Suffolk

Museum at Stony Brook, where they will be available to the general public, and will be especially valuable for historical research:

Portfolios, manuscripts, sketches and music; books from National Academy, pigments made from local clay, rocks and other materials to produce colors; old papers, catalogs; . . . 100 letters to Wm. Sidney Mount; letters and piece of wood from U.S.S. Constitution; violin and case with Micar Hawkins signature on it, he being the one who wrote the first American opera; painting, "Cherries," on wood; picture "Scare Crow," sketch in oil; sketches, Seabury's; 10 unsigned Mount sketches; Autobiography of Wm. S. Mount; sketch book made in 1831; catalog and descriptions of portraits; three diaries; local notes regarding dredging Stony Brook Harbor; miscellaneous writings; book regarding channel at Stony Brook; Genealogies of Long Island families; book regarding mixing colors and many other sketches.[2]

Also present at the sale was Richard McCandless Gipson, a former real estate agent and antiquarian who moved to the Stony Brook area that same year. At that time Gipson was associated with The New-York Historical Society, for which he acquired "over $300 worth of items, including letters written by Mr. Mount" at the sale.[3]

Surviving correspondence indicates that by January, 1944, Gipson was employed by Ward Melville, who later described him as "a non-resident curator engaged in securing material for the museum collections."[4] Gipson organized the Mount documents already in Mr. Melville's possession, which included seven autobiographical fragments and Mount's own catalog of his paintings, and which gave him a very complete listing of the artist's works even before Cowdrey and Williams' catalog was available. Equipped with this "shopping list," Mr. Gipson and Mr. Melville moved quickly. By June, 1944, they had acquired fifteen major Mount paintings, including *Christ Raising the Daughter of Jairus*, *Portrait of Jedediah Williamson*, *California News*, *The Mill at Stony Brook*, *The* Herald *in the Country* and *Just in Tune*, all of which are reproduced and discussed in the present volume. In January, 1945, The Metropolitan Museum of Art opened the exhibition "William Sidney Mount and His Circle" to mark the

publication of Cowdrey and Williams' catalog. The Melville Collection lent twenty-seven Mount oil paintings and studies, Mount drawings, prints, documents and various works by artists associated with Mount for that exhibition. Many of the works and documents had been acquired directly from the artist's family or from the families of collectors who had purchased paintings from the artist. The Melville Collection was always available to the public at The Suffolk Museum; Mr. and Mrs. Ward Melville formally donated a number of works from the Collection to the museum over the years, and Mr. Melville bequeathed the remainder of the Collection to The Museums (which became The Museums at Stony Brook in 1976) upon his death in 1977.[5] His generous bequest to The Museums also included many of the items in what is recognized to be the finest public carriage collection in the United States, and a wide variety of artifacts and documents relating to horse-drawn transportation history and Long Island history. Members of the Melville family continue to make generous gifts to The Museums at Stony Brook's collections and their donations have encouraged the generosity of others since the 1940s.

In 1945, shortly after The Metropolitan Museum of Art's Mount exhibition closed, The Suffolk Museum presented its first Mount exhibition, "The Mount Family." The title of the show is significant because several members of William Sidney Mount's family were artists: his brother Henry Smith Mount (1802–1841) gave William his first exposure to the art world of New York City; his brother Shepard Alonzo Mount (1804–1868) is best remembered as a portrait painter; and Henry's daughter Evelina Mount (1837–1920) painted landscapes and still lifes, and often copied her uncle William's paintings. William, Shepard and Evelina Mount often drew and painted the Hawkins-Mount House, making it one of the best documented houses of its period in the United States. In 1945 Ward Melville purchased the Hawkins-Mount House from Edward Buffet's widow, restored it and deeded it to the Stony Brook Community Fund, a charitable trust that leases it to The Museums at Stony Brook. Since that time The Museums has been responsible for an on-going program of preservation, research and interpretation for the Hawkins-Mount House, which is a National Historic Landmark.

In 1946, Alfred Frankenstein, the art historian and critic, first sought out the Melville Collection. In 1975 he

published his monumental work, *William Sidney Mount*. His five hundred-page, fully illustrated study is most useful for its chronological presentation of Mount's diaries and correspondence. In the 1960s, Bartlett Cowdrey had the Mount papers at Stony Brook microfilmed for the Archives of American Art.

In a relatively short time a remarkable collection of unusual depth was assembled in Stony Brook. The Museums at Stony Brook's art collection now includes more than one hundred oil paintings and studies and nearly four hundred drawings by William Sidney Mount. It also includes works that number in the hundreds by other artist-members of the Mount family. The Museums Mount archives includes Mount family papers that complement an estimated three-quarters of William Sidney Mount's extant notebooks, diaries and correspondence, books from his library and several hundred popular tunes (mostly for the fiddle) that he collected and transcribed. Of particular interest are Mount's designs, notes and correspondence on the "hollow-backed" violin that he patented in 1852. An 1857 version of this instrument, which he called the "Cradle of Harmony," and fragments of other versions of it are part of The Museums collection.

In addition to Mount's passion for music, his papers reveal his wide-ranging interests in perspective, color theory, mathematics, engineering, spiritualism and phrenology. Above all, they show his never-ending fascination with the techniques of painting and his constant striving to master his craft. Also apparent is Mount's love of nature, which he always called the artist's best teacher. Very little overt interest in human nature is revealed; Mount's acute observations of his neighbors went directly into his paintings.

It is unusual that such a variety of material reflecting the breadth of one man's interests, as well as the intellectual currents of his day, is preserved to support and illuminate an unequaled collection of his art. It is fortunate that this collection remains in the area where the artist lived and worked; and it is appropriate that the collection is studied and exhibited in a museum devoted to nineteenth century American history, where William Sidney Mount can be appreciated not only as an artist, but as a man of his time.

Susan Stitt
Director
The Museums at Stony Brook

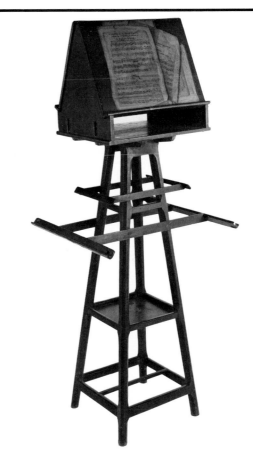

1 John I. Baur, Foreword, *Catalogue of an Exhibition of Drawings and Paintings by William Sidney Mount, 1807–1868*, by Brooklyn Museum, Exh. Cat. (Brooklyn, N.Y.: Brooklyn Museum Press, 1942), 3.
2 "Interest of Antique Collectors Drawn at Mount Estate Auction," *Port Jefferson Times*, 18 Nov. 1943, 1, 7.
3 "Interest of Antique Collectors Drawn at Mount Estate Auction."
4 Ward Melville, Letter to George Cray, 13 Feb. 1959, Gipson Papers, The Museums at Stony Brook.
5 During the construction of the present Art Museum of The Museums at Stony Brook, which opened in 1974, the Mount collection was put in storage and was not exhibited in Stony Brook.

William Sidney Mount late 1850s
Holmes and Company, New York City
Ambrotype
8.2 × 6.3 (3¼ × 2½)
Museums Collection

William Sidney Mount (1807–1868)

When William Sidney Mount was born, in 1807, American painting depended largely on European models. Beyond portraiture, European, and particularly English, academic tradition dictated that grandiose historical, religious and literary subjects were most appropriate for serious artists. Subjects from everyday life, which had been extremely popular in the Netherlands in the seventeenth century, were generally disdained by English artists and their aristocratic patrons, at least until George IV (1762–1830, reign 1820–1830) began to collect Dutch paintings. Paintings of ordinary people doing ordinary things, usually called genre paintings, became popular in England with the work of the influential Scottish artist, Sir David Wilkie (1785–1841).

In time, these changes in artistic taste affected the development of American art. Often prints made from paintings were the medium by which artistic ideas were transmitted from the old world to the new. The first of Wilkie's paintings known to have been reproduced as a print was *The Jews Harp*, engraved in 1809.[1] At least twenty-seven more of Wilkie's paintings were made into prints, some of which were published in magazines, and some of which were even used as transfer decoration on earthenware dishes.

Genre subjects were first produced in America in the decorative and commercial arts. Young ladies worked everyday scenes in embroideries, and sign and ornamental painters depicted such scenes on shop signs, fire-fighting vehicles and window shades. Paintings of genre subjects were exhibited sporadically in the few public exhibitions held in Boston, New York and Philadelphia, but the first American-born painter to specialize in painting scenes of everyday life was William Sidney Mount.

William Sidney Mount was born in Setauket, Long Island, the fourth son of Thomas Shepard Mount and Julia Ann Hawkins Mount. His father's family had come to Long Island from New Jersey, and his mother's family was among the earliest English settlers on the island. William's father was a farmer and an innkeeper, who, according to William, was passionately interested in music. Thomas S. Mount died in 1814.

About 1815, when William was eight years old, he was sent to school in New York City. There he lived with his uncle Micah Hawkins (1777–1825). Hawkins had been trained as a carriage maker and later kept a grocery store and tavern. Music was his greatest interest. He was active in most of the city's musical societies and integrated music into every aspect of his life; it is even said that he had a piano built into his grocery store counter. His crowning accomplishment was *The Saw Mill, or a Yankee Trick* which is sometimes called the first successful American opera, or operetta, and which was produced a year before his death.

In 1816 Thomas Mount's estate was sold, and his widow moved her five children to her father's Stony Brook homestead, known today as the Hawkins-Mount House. In his autobiographical notes, preserved in the archives of The Museums at Stony Brook, Mount wrote that he left New York at that time to be a "farmer boy" for his mother.

In the same autobiographical notes Mount recorded his first exposure to art:

> My Sister, Mrs. Ruth H. Seabury, although the youngest, displayed the first taste in painting. When at the early age of eleven she took lessons of Mrs. Spinola. then you could have seen me looking over my sisters shoulder, with my straw hat in hand to see how she put on the colours. A picture was then and always has been to me an object of great attraction. I had no idea at that time of ever becoming a painter, but, my mind from my earliest recollection was always awakened to the sublime and beautiful in nature.[2]

The Museums collection includes a watercolor by Ruth Mount (illustrated p. 14) which is a copy of a print after a painting by—significantly—Sir David Wilkie. The painting, which is unlocated today, is known from an engraving by François Janet titled *L'Orage* (*The Storm*, illustrated p. 14), which was issued in the French magazine *Hommage Aux Dames* about 1820.[3] The Museums watercolor is clearly inscribed "by Miss Ruth H. Mount." Ruth married Charles Saltonstall Seabury in 1826, so she must have painted the watercolor before that—several years before William himself began to paint.

William's eldest brother, Henry Smith Mount (1802–1841), was the first member of the family to make a living as an artist. He trained with the New York City sign and portrait painter Lewis Child (who painted a portrait of Micah Hawkins which is now in The

L'Orage
François Janet (after a painting by Sir David Wilkie)
Engraving
12.3 × 7.8 (4⅞ × 3⅛)
Published by Louis Janet in *Hommage aux Dames*, Paris, c. 1820
Collection of Malcolm Stearns, Jr.

L'Orage (The Storm) 1820–26
Ruth Hawkins Mount Seabury (after an engraving by François
 Janet)
Watercolor on paper
35.5 × 29.2 (14 × 11½)
Gift of Mary Rackliffe and Edith Douglass, 1970

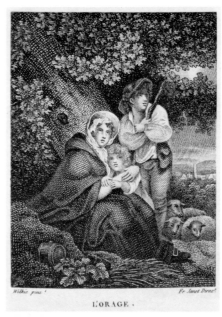

L'ORAGE.

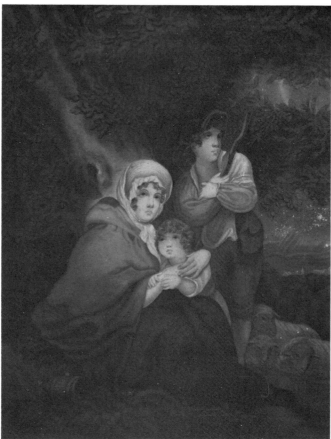

Museums collection), and set up in business with William Inslee. Inslee owned a set of large engravings by the English artist William Hogarth (1697–1764), which may well have been the source for one of William's earliest drawings, a sheet of heads copied from details of several Hogarth prints (n.d., The Museums at Stony Brook, illustrated p. 15). Henry Mount also collected prints and sometimes used them as a basis for the compositions of his paintings.

In 1824 William's mother apprenticed the seventeen-year-old William to his brother Henry. William stayed in Henry's shop until 1827. He progressed rapidly in the trade and at the same time started to draw in pencil and in chalk on dark-painted panels. Also at this period William attended his first exhibition of paintings. The exhibition was held at the American Academy of Fine Arts. The American Academy exhibited paintings by American artists—particularly its president, John Trumbull—and some European paintings. Often the European paintings in American collections and exhibitions were copies or fakes, but during this period several authentic and important European paintings were lent to the American Academy by Joseph Bonaparte, who at the time lived near Bordentown, New Jersey as the Comte de Survilliers.

At the time of its foundation in 1802, the American Academy's primary mission had been to encourage progress in the fine arts, specifically by providing examples of art works from which young artists could learn. The Academy collected paintings, but its directors were even more anxious to acquire engravings and plaster casts of Greek and Roman sculpture. In the tradition of the European academies, the American Academy expected aspiring painters to spend several years learning to draw from prints and plaster reproductions from the "antique."[4] Unfortunately the directors of the American Academy were almost all businessmen who thought it sufficient encouragement to art to make the Academy's facilities available to students for a scant three hours a day, at one point at the inconvenient time of six to nine in the morning. In reaction to these limitations a number of artist-members of the Academy formed the New-York Drawing Association in 1825. By 1826 the Drawing Association had evolved into the National Academy of Design, an artist-controlled organization with a school and annual exhibitions—much more diverse and vital than the repe-

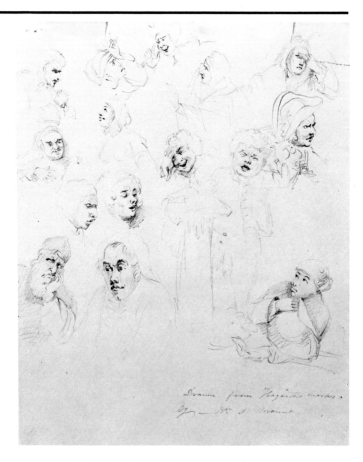

Drawn from Hogarth's Works n.d.
Pencil on paper
25.4 × 20.1 (10 × 7¹⁵⁄₁₆)
Inscription: *Drawn from Hogarth's Works*
Bequest of Dorothy DeBevoise Mount, 1959

titious shows of the American Academy—that continue to this day. Among the new academy's first students in 1826 and 1827 was William Sidney Mount. William worked at the National Academy copying prints and plaster casts in the odd hours he could spare from sign painting. By 1827 Henry realized that his younger brother had a promising career as a fine artist, and William left his shop. William then returned to Stony Brook to regain his health, which was always delicate and strained by long periods in the city. In Stony Brook, in 1828, he completed his first painting, *Self Portrait with Flute* (The Museums at Stony Brook, illustrated p. 34), and a picture (as opposed to a portrait, in the terminology of the period), *Christ Raising the Daughter of Jairus* (The Museums at Stony Brook, illustrated p. 36). The latter painting, though small and rather stiff in execution, is of an ambitious subject in the tradition of Benjamin West's *Christ Healing the Sick in the Temple* (1815), which became one of the best-known paintings in the country when the artist gave it to Pennsylvania Hospital in 1818. In 1828 William probably knew West's painting only through description or reproduction; he did eventually see it on a visit to Philadelphia in 1836.

In 1828 Henry was elected an Associate of the National Academy of Design, where he used his influence to have *Christ Raising the Daughter of Jairus* included in the Academy's Annual Exhibition of that year.[5] The reaction of the Academicians, especially that of their president, Samuel F. B. Morse, must have been most gratifying to the young artist: "The President expressed himself pleased with it, and said as respects design, he had not seen its equal amongst any of the *Modern masters*."[6]

About 1828 Mount entered the studio of Henry Inman (1801–1846), the well-known painter of portraits and, later, genre subjects. The experimental venture lasted only about a week. Mount left Inman's studio, he said, to preserve his originality. Relations between the two artists remained cordial, however, and Inman occasionally visited Stony Brook to shoot quail.

By 1829 William had painted a total of seven paintings with historical and literary subjects—a scene from *Hamlet*, a scene from *Pericles*, *The Death of Hector*, *Crazy Kate*, *Celadon and Amelia*, *Saul and the Witch of Endor*, as well as *Christ Raising the Daughter of Jairus*.[7] He then gave up historical and literary subjects for portrait painting:

> But continuing in historical painting I found would not even furnish me with bread of course I was obliged to relinquish it for portrait painting. it was not wholly a sacrifice of my talents for I found that portraits improved my colouring and for pleasurable practice in that department I retired into the country to paint the mugs of Long Island yoemanry.[8]

William's brother, Shepard Alonzo Mount (1804–1868), who was apprenticed to James Brewster of New Haven, Connecticut, to learn harness making, moved to New York about 1827, when Brewster expanded his business to that city. By 1829 Shepard was a student of drawing at the National Academy, and in the spring of 1829, apparently gave up his first trade to set up in business with his brother William:

15

Apollo 1826
Charcoal and pencil on paper
36.8 × 23.3 (14½ × 9⅛)
Inscription: *Drawn from an engraving/by Wm. S. Mount—1826*
Bequest of Dorothy DeBevoise Mount, 1959

Rustic Dance After a Sleigh Ride 1830
Oil on canvas
55.9 × 69.2 (22 × 27¼)
M. and M. Karolik Collection, Courtesy of Museum of Fine Arts, Boston

Dance in a Country Tavern 1835–36
George Lehman (after a painting by John Lewis Krimmel)
Lithograph
20.0 × 27.5 (7¹⁵⁄₁₆ × 10⅞)
Courtesy of Historical Society of Pennsylvania, Philadelphia

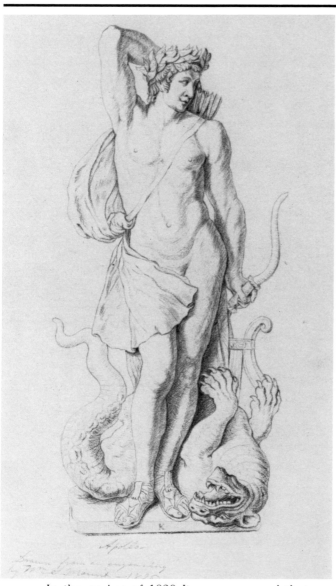

go to work. Shepard painted some pieces of still life, while I endeavoured to call up a dead man for a friend. I recollect of painting the portrait of a gentleman for the price of the materials. Yet still this extent alone of patronage would not make the pot boil. . . .[9]

Shepard soon found that it was easier to obtain portrait commissions if he traveled to his sitters, rather than waiting for them to come to him. He continued to specialize in painting portraits for the rest of his career. William, on the other hand, found a new course to pursue—one that he could follow nowhere better than in Stony Brook—and one that would gain him his unique position in the history of American art. While he continued to paint portraits throughout his career, he now began to paint scenes from everyday life that not only became immediately popular, but continued to be in demand from Mount and from other American genre painters for whom he prepared the way.

In 1828 William Sidney Mount painted *A Girl at the Spring Reading a Love Letter*. The painting is now lost but was probably similar to *Girl With Pitcher* (1829, The Museums at Stony Brook, illustrated p. 38). *Girl With Pitcher* does not capture the essence of life in rural Stony Brook as his later works would; it shows no action, nor does it tell a story. It is, rather, a sweetly sentimental figure piece, somewhat similar in feeling to *L'Orage*, the Janet print after Wilkie. The figure in *Girl With Pitcher* is more a graceful doll than flesh and blood, but the setting is real—a wing of Mount's own house, authentic down to the hardware that can still be seen on the door.

The next year, 1830, Mount took an important step toward the kind of genre painting that would make him famous. In *Rustic Dance After a Sleigh Ride* (The Museum of Fine Arts, Boston, illustrated p. 17), Mount painted a crowd of figures dressed in their rustic finest and animated by a black musician, a theme that Mount would paint, with progressive realism, throughout his career. The figures in this work are still rather doll-like, but supple, and they are engaged in an activity that Mount would have seen frequently and doubtless would have enjoyed as a participant. In *School Boys Quarreling* (The Museums at Stony Brook, illustrated p. 41), which he painted later the same year, Mount reduced the number of figures and achieved a more

In the spring of 1829 It was proposed that my Brother Shepard, and myself should take a room in Cherry St near franklin square and set up our easels for chance customers. Our notification to the public was W.S. and S.A. Mount, portrait painters, upon a small gilt sign which I painted myself. We sat from day to day in idleness discoursing on the various styles of art, and wondering why so many should pass by without some one droping in to encourage native talent. At length being disgusted at the tramping of hoofs upon the pavements—we concluded to

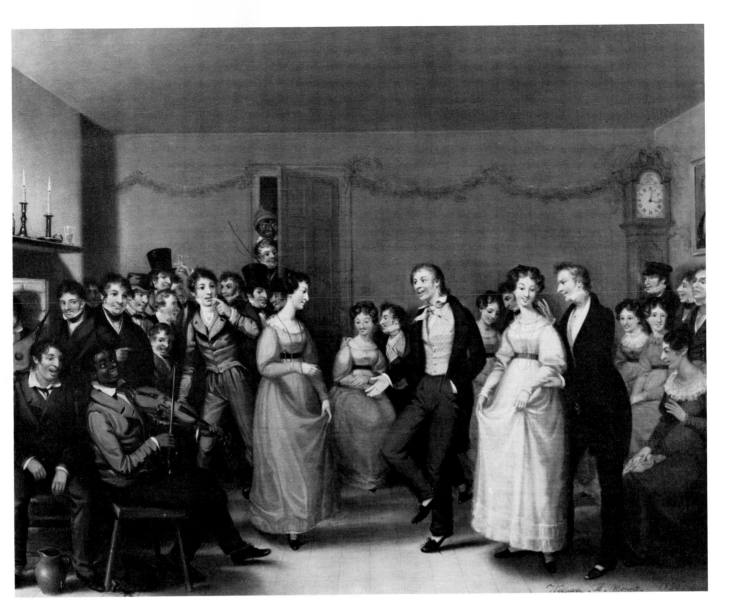

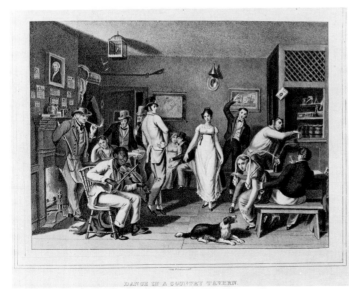

DANCE IN A COUNTRY TAVERN.

classically balanced composition. Mount's sources for *Rustic Dance After a Sleigh Ride*, beyond his observation of life around him, may be suggested by the work of other artists who were just beginning to paint, draw and engrave genre subjects at the time.

John Lewis Krimmel (1789–1821), who emigrated from Wurtemburg to Philadelphia in 1809, was one of the first artists to paint fully developed genre scenes in the United States.[10] Several of the paintings he exhibited in Philadelphia, New York and Boston were copies after Sir David Wilkie's paintings, which Krimmel, like Mount, would have known through prints. Compositions of his own invention include such scenes of city life as *Election Scene in Philadelphia* (1815, The Henry Francis du Pont Winterthur Museum, Winterthur, De.). Mount recorded that seeing this genre painting was one of the highlights of his 1836 trip to Philadelphia: "Mr Lawson showed me several fine pictures by the late John Lewis Krimmel, one in particular, 'a Philadelphia election.' It is worth going the whole distance to see. . . ."[11]

Krimmel also painted such rustic scenes as *The Quilting Party* (1813, The Henry Francis du Pont Winterthur Museum) and *Country Frolic and Dance* (date and present location unknown). The visual similarities between *Country Frolic and Dance*, known today by a lithograph after it entitled *Dance in a Country Tavern* (1835–36, illustrated here), are so obvious that most

17

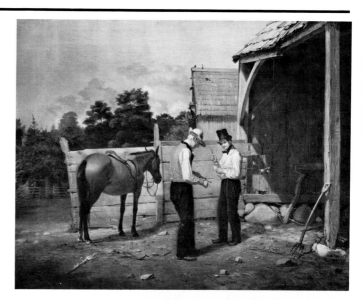

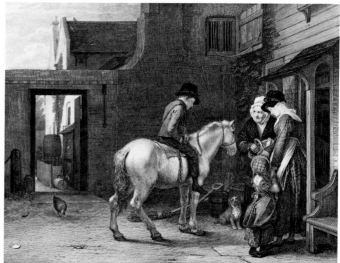

art historians agree that Mount used Krimmel's painting as the model for *Rustic Dance After a Sleigh Ride*.[12] Much discussion has been devoted to which of Krimmel's paintings Mount could have seen, and where and when he may have seen them.[13] Mount's only direct written reference to Krimmel's work is quoted above. The more telling reference, which is clear in Mount's adaptation of Krimmel's *Country Frolic and Dance* in his own *Rustic Dance After a Sleigh Ride*, can only be to Krimmel's painting itself or to a print or other copy of it, now lost, that was made before Childs and Lehman of Philadelphia published the lithograph *Dance in a Country Tavern*.

Mount was closely associated with artists and others in Philadelphia and in New York who would have known Krimmel's work at an early date. Pierre Flanden, a New York dealer, is known to have handled Krimmel's work. Mount recorded that he sold *School Boys Quarreling* (1830, The Museums at Stony Brook, illustrated p. 41) to "P. Flanden, Esqr., New York," in 1830, and that he painted "Mrs. Flanden" in 1830 and "Portraits of the two Miss Flandens" in 1832. It is not known whether Mount knew Flanden before 1830, or whether he knew anyone else who could have introduced him to Krimmel's work.

David Claypoole Johnston (1789–1865), an artist and an actor, is another possible link between Mount and the artists and printers of Philadelphia, where Krimmel was a leading figure until his death in 1821. Johnston illustrated some of the published versions of Mount's musical uncle Micah's productions. If Mount did not know the man, at least he knew his work. Johnston exhibited genre paintings in exhibitions as early as 1829, but he is best known for his satirical and theatrical prints.[14]

In 1829 other artists associated with Mount exhibited paintings whose titles suggest genre subjects: Henry Smith Mount exhibited *The Idle Boy* at the National Academy, and his business partner William Inslee exhibited *The Beggars* in the same exhibition. Judging from their titles, both of these unlocated pictures could well have been genre paintings. Moreover, many of Mount's earliest associates were commercial artists and illustrators, tradesmen relatively low in the artistic hierarchy of the period who did not disdain subjects from everyday life that may have been considered beneath more academically trained and "aristocratically" patronized "fine" artists.

Mount's early development and associations suggest some answers to the crucial question of why he became the first important American-born artist to specialize in painting scenes from everyday life. The reasons for his success, beyond his unquestioned technical skill, involve the patrons of his period, the critical response to his paintings and the distribution of popular prints that reproduced his paintings.

In 1830, when *Rustic Dance After a Sleigh Ride* was exhibited at the National Academy of Design, patterns of artistic patronage in the United States were changing. New commercial fortunes were being made,

often by vigorous and ambitious men who had been raised on outlying farms, and whose tastes tended to be different from those of collectors with long-established seaboard fortunes. Mount's scenes of rural life made a direct and nostalgic appeal to the new magnates, and his fine craftsmanship assured them that they were getting good value for their money. These new collectors often had less formal education, were less culturally conservative and were less likely to look to Europe for artistic guidance, although they did collect European (or purportedly European) paintings.

One of Mount's earliest and best-known patrons was Luman Reed (1784–1836), whose generosity and friendly interest encouraged such artists as Thomas Cole, Asher B. Durand and George Flagg.[15] Between about 1832 and his unexpectedly early death in 1836, Reed formed an outstanding collection of contemporary American art. His collection was open to the public at specified hours. After his death his friends were able to keep it largely intact and, ultimately, to place it in The New-York Historical Society. Reed involved William and Henry Mount in the decoration of the third floor picture galleries of his Greenwich Street house. He also purchased William's *Bargaining for a Horse* (1835, The New-York Historical Society, New York, illustrated p. 18) and *Truant Gamblers* (or *Undutiful Boys*, 1835, The New-York Historical Society). The former painting is a striking example of Mount's occasional use of prints after Wilkie's paintings (like *The Errand Boy*, illustrated p. 18) in devising his own compositions.[16] Mount recorded that Reed paid more than his asking price for *Bargaining for a Horse*—an experience repeated with other patrons and always recorded by Mount with satisfaction. Reed offered to pay for Mount to travel and to study in Europe, an experience which many of the most ambitious American artists of the period found necessary to their development. Mount refused Reed's and others' similar offers during his career, writing:

In my opinion a short visit to Europe will not hurt anyone. I have often been asked, "have you been abroad"? A visit to Europe would be gratifying to me, but I have had a desire to do something in art worthy of being remembered before leaving—for fear I might be induced by the splendor of Europeian art to tarry too long, and thus lose my nationality. We have nature, it

speaks to every one and what efforts I have made in art have been appreciated by my countrymen—Originality, thank God, is not confined to any one place or country and this makes it very comfortable for those who are obliged to stay at home.[17]

In fact, Mount traveled very little. He recorded an 1834 trip to Athens, Pennsylvania; Ithaca, New York; and the Catskills, where he visited Thomas Cole, the father of the "Hudson River School" of landscape painting. (The development of an American school of landscape painting has been said to parallel the development of American genre painting.) In 1836 he visited Philadelphia, where he met several artists, including Thomas Sully, Thomas Birch and Alexander Lawson. In 1839 he traveled to Boston, where he met artists Washington Allston, George Flagg and Francis Edmonds. (Edmonds often painted genre subjects similar to Mount's.) The last trip of any length that Mount recorded, in 1843, took him to Hartford, Connecticut; Albany, New York; and the Catskills. Although Mount often thought that life in the city would stimulate him to do more and better work, invariably a stay of any length would send him exhausted back to the country. Beginning some time in the 1830s, he stayed mainly in the Stony Brook area, either in the Hawkins-Mount House or boarding with family or friends.[18]

Mount's accounts of his travels document his contact with other artists. In New York, his name appears peripherally in the annals of arts organizations. His relationships with other artists were generally of a more individual, personal character. One particularly close artist friend was Charles Loring Elliott (1812–1868), who painted several portraits of Mount (1848, illustrated frontispiece).

Generally Mount declined to supply personal information to his would-be biographers and critics. Nonetheless, accounts of Mount's life and career appeared in many art publications during his lifetime and for some years thereafter. Charles Lanman, who is probably best remembered today for having been the personal secretary of Daniel Webster, wrote one particularly interesting sketch that appeared after Mount's death. Lanman was a painter himself; he shared many other interests with Mount, especially fishing. Lanman's biographical account, based on years of intimate friendship with Mount, probably gives the best picture

**Silhouette of Charles L. Elliot, W.S. Mount and
 Mrs. C.L. Elliot** 1844
Auguste Edouart
Cut paper silhouette on paper
26.5 × 33.0 (10⁷/₁₆ × 13)
Museums Collection

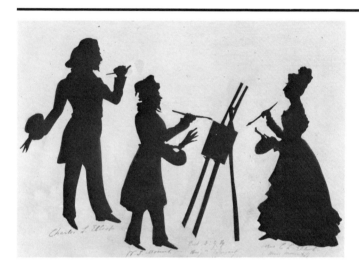

of the artist and the man published in the nineteenth
century:

> After profiting by models from the antique, and
> the few good pictures to which he had access,
> as well as by the friendly advice of John Trum-
> bull, he began to look to nature alone for his
> inspiration; and from that time until the day of
> his death she was his only guide and teacher.
> He was unquestionably one of the most original
> artists of his day, and exerted a happy influence
> on the public taste. He was the pioneer, and
> continued the unequalled master in his special
> department. . . . He was an enthusiastic Amer-
> ican in his feelings, and a lover of fun and
> humor, and these qualities were almost invari-
> ably visible in his productions.[19]

A more telling barometer of how Mount's work was
received in his time is the critical press of the period.
Much of what was written about his work was neither
perceptive nor acute. His critics were most interested
in telling the stories they found in Mount's paintings. In
general, they received his work enthusiastically, es-
pecially early in his career. Critics compared him to
seventeenth century Dutch genre painters and called
him "the American Wilkie."[20] Some critics thought he
wasted his skill on genre subjects, and that his color
was cold and harsh. Such negative comments, how-
ever, were generally caveats in largely favorable re-
views. During the last ten years of Mount's life changes
in taste and an actual decline in his powers combined

to make such notices as his work received less favora-
ble than they had been before.

Another aspect of Mount's success and wide-
spread popularity was the reproduction of his paintings
as popular prints. As early as 1834, reproductions of
Mount's paintings began to appear in magazines and
gift books. Ten years later, *Farmers Nooning* (1836, The
Museums at Stony Brook, illustrated p. 52) was made
into a large-format engraving that was distributed by the
Apollo Association. The Apollo Association developed
out of the moribund American Academy of the Fine
Arts and later became the American Art-Union. The
American, one of several art unions active in the United
States at that period, was basically a lottery organiza-
tion. The Art-Union used membership dues to pur-
chase a number of works from its regular exhibitions.
Members then had the opportunity to win the pur-
chased paintings by lottery. The American Art-Union
also distributed prints to all its members. The distribu-
tion of these prints brought the work of American art-
ists, including Mount, to a much wider audience than
they had ever enjoyed before.

Later several of Mount's paintings were re-
produced as colored lithographs by the French firm of
Goupil, Vibert and Company (later Goupil and Com-
pany). Goupil had galleries in several European cities,
and in New York, where their agent, William Schaus,
became a good friend of William Sidney Mount. Several
of Mount's paintings, including one of his best-known,
The Banjo Player (1856, The Museums at Stony Brook,
illustrated p. 72), were commissioned by Schaus spe-
cifically to be made into prints. Mount would sell the
copyright to a work to Goupil (later to Schaus, who
went into business on his own), who sent the actual
painting to Paris, where it was copied on a lithographic
stone. The painting was returned to Mount, who could
then sell it to a collector. Paintings like *The Banjo
Player* were called "fancy pictures" because they were
portrayals from the artist's imagination, not actual por-
traits. All but two of Mount's "fancy pictures" feature
black musicians; the publishers called these pictures
"Ethiopian Portraits." They were images that seemed to
many Europeans to be typical of America. Although
Mount thereby supplied an international audience with
what might seem to have been stereotypes, his works
have nothing of caricature about them. It has been
noted that Mount was the first American artist to portray
black subjects with dignity. Because prints after

20

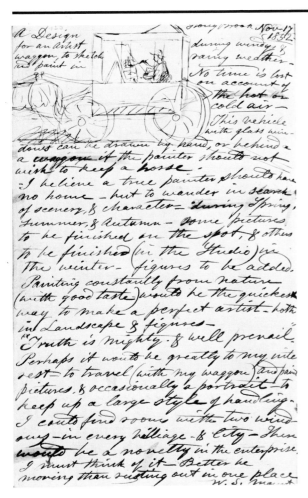

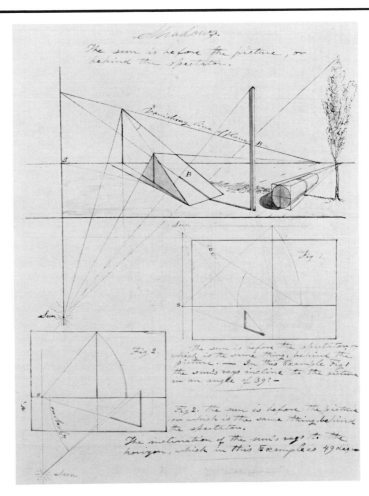

Mount's paintings were sold throughout Europe as well as in the United States, Mount was one of the few mid-nineteenth century American artists whose work was known abroad.

Mount's work achieved great popularity during his lifetime. He was the first American-born painter to specialize in painting pictures of ordinary Americans doing ordinary things. In its original form his work appealed directly to a new class of patrons. In its printed form it became available and proved to be attractive to thousands who could not afford to own paintings and who rarely saw them on exhibition.

Mount would have been a great painter regardless of the subjects he chose, regardless of the felicitous coincidence of his innovative subject matter with the homely tastes of his up-and-coming patrons, and re-gardless of the widespread distribution of popular prints that reproduced his paintings. The technical excellence of his art was the result of hard work and a careful study of nature. A century after his death, art historian Barbara Novak wrote:

> It is important, therefore, to take the hayseed out of his hair, to reinstate him as a sophisticated designer, a thoughtful painter, whose best works can be measured formally against other works of quality in the history of art. . . .[21]

Mount believed in a direct study of nature as his basic guide in art. As early as 1833, he painted the landscape in a major painting—*Long Island Farmer Husking Corn* (The Museums at Stony Brook, illustrated p. 50)—directly out of doors.[22] Later he wrote:

> Of painting in the open air—I am the first Amer-

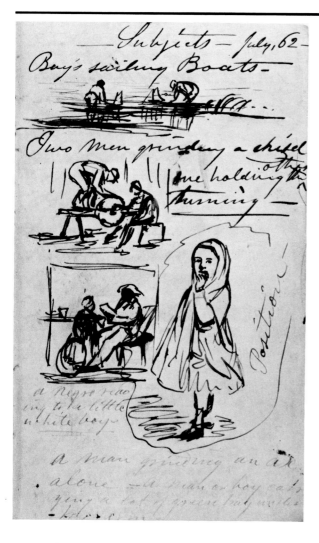

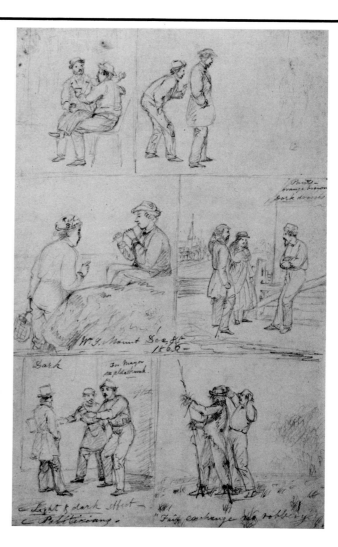

ican I know of that painted directly, that is, made studies in the open air with oil colors. An artist in painting a landscape in the open fields is animated by nature and can do more in the right spirit, in the same length of time, than he can possibly accomplish in his paint room from memory or from his sketches.[23]

Late in his life, Mount designed and had built a portable studio, equipped with a heating stove and a plate glass window, which he could have pulled from place to place, and which allowed him to work in any weather.

Mount recorded everything: in his journals the fluctuations of the weather and his delicate health; in

his notebooks the principles of perspective and color theory; in his letters the political and cultural events of the day. Mount's drawings and sketches, which he often dated, and saved religiously, provided him with a store of visual material drawn directly from nature. In a similar manner, he jotted down subjects for paintings in his journals, later drawing a line through each idea that evolved into a finished work. Some of his sketches —sometimes as many as fifteen to a sheet of paper— developed his ideas further. Once embarked upon a picture, he executed pencil sketches and oil studies, some of which accompany the plates of his paintings in this volume. Evident in all of his preliminary explorations is an unremitting effort, a constant reference to the art of the past and to all he could glean from the

William Sidney Mount and Others in a Sleigh late 1850s
R.A. Lewis, New York City
Hand-colored ambrotype
8.4 × 10.8 (3¼ × 4¼)
Gift of Mrs. Robert Smith (Jae Thompson Smith) in memory of
 Miss Etta Sherry, 1980
Photograph by Michael Madigan, MPS/Island Color

practical and theoretical sciences to which he was exposed. Upon this stage, with hard-won technical skill and meticulous craftsmanship, he set real people: some of them actors in small, ordinary dramas; some of them cloaked in the sentimentality and moral lessons that were the props of his time; and the best of them in simple, universal and timeless activity or repose. All of this he accomplished with an awareness, diligence and humility that make him one with his still living subjects, with the present and with generations unborn, to whom he will continue to speak clearly and simply.

David Cassedy
Curator
Art Collection and Archives
The Museums at Stony Brook

1 To date the best discussion of prints made from Wilkie's paintings and their influence on Mount's work is Catherine Hoover's article, "The Influence of David Wilkie's Prints on the Genre Paintings of William Sidney Mount," *The American Art Journal*, 13, No. 3 (1981), 4–33.

2 William Sidney Mount, autobiographical notes, n.d., n. pag., ms, The Museums at Stony Brook. This and all following manuscript items listed as belonging to The Museums at Stony Brook are listed fully in David Cassedy and Gail Shrott, *William Sidney Mount: Annotated Bibliography and Listings of Archival Holdings of The Museums at Stony Brook* (Stony Brook, N.Y.: The Museums at Stony Brook, 1983).

3 Karen M. Jones, ed., "Collectors' notes," *Antiques*, 120 (1981), 550, 554. This column, mainly concerned with the use of prints after Wilkie's paintings in the decoration of transfer-printed earthenware, identifies the previously unknown Janet print after the lost Wilkie painting.

4 William Sidney Mount painted from the American Academy's casts in 1833, but he found that doing so strained his eyes. He also received some encouragement from the Academy's president, John Trumbull, who gave the young artist a copy of the engraving after his own *The Death of General Montgomery* (engraving, 1798, The Museums at Stony Brook).

5 The *National Academy of Design Exhibition Record 1826–1850* (New York: The New-York Historical Society, 1943), II, 36, gives 1828 as the date of Henry Mount's election as an Associate of the Academy. In his autobiographical notes William Sidney Mount stated that Henry was an Associate the year before. As he wrote his notes some twenty years after the events of the 1820s, however, Mount sometimes made small errors in dates.

6 Mount, autobiographical notes, n.d., n. pag. It is not clear from Mount's reminiscences whether Morse commented on Mount's painting, *Christ Raising the Daughter of Jairus*, or on his pen and ink sketch for the painting (1828, The Museums at Stony Brook, illustrated p. 37). The painting was Mount's first to be exhibited at the National Academy of Design in 1828. Mount continued to exhibit his work at the National Academy until his death: in thirty-two years he exhibited a total of 153 paintings.

7 Of the seven history paintings Mount recorded in documents that survive, four—a scene from *Hamlet*, a scene from *Pericles*, *The Death of Hector*, and *Crazy Kate*—are lost. *Celadon and Amelia* (1828) and *Christ Raising the Daughter of Jairus* (1828) are in the collection of The Museums at Stony Brook; *Saul and the Witch of Endor* (1828) is in the collection of the National Museum of American Art, Washington, D.C.

8 Mount, autobiographical notes, n.d., n. pag.

9 Mount, autobiographical notes, n.d., n. pag.

10 Milo Naeve, "John Lewis Krimmel: His Life, His Art and His Critics," M.A.T. University of Delaware 1955, is the only study of Krimmel's work to date.

11 Mount, autobiographical notes, n.d., n. pag.

12 The relationship between Krimmel's *Country Frolic and Dance* and Mount's *Rustic Dance After a Sleigh Ride* was first explored by Donald Keyes in his article, "The Sources for William Sidney Mount's Earliest Genre Paintings," *The Art Quarterly*, 32 (1969), 258–68.

13 To date the most thorough published summary of the possible connections between Mount's work and Krimmel's, and between Mount's work and Wilkie's, through Krimmel, is Catherine Hoover's article listed above.

14 William Hayes Fogg Art Museum, Cambridge, Massachusetts, *Art in New England: New England Genre*, Exh. Cat. (Cambridge, Mass.: Harvard University Press, 1939), 40–41. Naeve, whose Master's thesis is listed above, notes in it (187) that Johnston owned Krimmel's *Election Scene in Philadelphia* in 1848, perhaps another version of the painting now at Winterthur.

15 For a recent full account of Luman Reed as a collector and as a patron see Wayne Craven, "Luman Reed, Patron: His Collection and Gallery," *The American Art Journal*, 12, No. 2 (1980), 40–59.

16 This comparison was made by Catherine Hoover in her article listed above.

17 Mount, autobiographical notes, n.d., 14.

18 Upon the death of Julia Ann Hawkins Mount in 1841, William Sidney Mount inherited a quarter share of his mother's interest in the Homestead. Equal shares went to each of his surviving brothers, Robert Nelson Mount and Shepard Alonzo Mount. The fourth quarter went to the six children of the other brother, Henry Smith Mount, who had died earlier that year. Specifically, William had the use of the "room he now occupies" (1841) and of his attic studio.

19 Charles Lanman, *Haphazard Personalities: Chiefly of Noted Americans* (Boston: Lee and Shepard, 1886), 169–70.

20 In the press of the period William Sidney Mount was called "the American Teniers" as well as "the American Wilkie." Not only did the three artists paint similar subjects—Teniers in the Netherlands in the seventeenth century and Wilkie in England in the early nineteenth century—they sometimes employed similar compositional devices, most notably the "box stage." All three often placed their figures in a room or other box-like setting, omitting the wall that would otherwise separate the "actors" from the "audience," as on a stage. Mount's paintings set in barns, e.g. *Dance of the Haymakers* (1845, The Museums at Stony Brook, illustrated p. 64), are good examples of this type of composition. The collection of The Museums at Stony Brook includes seven theatrical subjects that Mount drew in New York City in the 1820s and 1830s. These drawings may suggest the theater stage itself as a source for Mount's use of the "box stage" composition, especially as many of the characters Mount would later paint can be found in the "Yankee drama" that was developing in New York City in the 1820s. Some of the theatrical associations that may have been important to Mount's early development as a genre painter have recently been suggested by historian Peter Buckley, who further points out an almost exact correspondence between a scene from the Yankee drama *Forest Rose* (1826) and Mount's painting *The Sportsman's Last Visit* (1835, The Museums at Stony Brook, illustrated p. 54).

21 Barbara Novak, *American Painting of the Nineteenth Century: Realism, Idealism and the American Experience* (New York: Praeger Publishers, Inc., 1969), 149.

22 William Sidney Mount, Diary/Journal 1848–1857, 14 Nov. 1852, n. pag., ms, The Museums at Stony Brook. This was formerly known as The Whitney Journal.

23 William Sidney Mount, notes on painting in the "open air," n.d., ms, The Museums at Stony Brook. At the end of this passage Mount later added in pencil, "before he has much experience."

Chronology

	William Sidney Mount and His Family	New York/*New York City
1807	William Sidney Mount is born in Setauket (The artist is listed subsequently as Mount.)	Robert Fulton's steamboat *Clermont* begins a round-trip voyage between Albany and New York City
1808		*John Jacob Astor incorporates the American Fur Company
1809		
1810		
1811		
1812		
1813		British blockade the east coast of the U.S. and send patrols out on Long Island Sound
1814	Thomas Shepard Mount dies	Micah Hawkins' "The Siege of Plattsburgh" (or "Backside Albany") performed in commemoration of American victory
1815	Mount goes to New York City to attend school; lives with his uncle, Micah Hawkins	
1816	Julia Hawkins Mount takes her children to live in her father's house in Stony Brook; Mount returns to Stony Brook from New York City	
1817		Construction on the Erie Canal begins
1818		
1819	Mount observes his sister's watercolor lessons	
1820		
1821		
1822		*The Bread and Cheese Club for writers and artists is founded in New York City

United States	Europe
Thomas Jefferson is third President of the United States Embargo Act of 1807 Boston Athenaeum is founded	Jacques Louis David paints *Coronation of Napoleon*
	Extensive excavations begin at Pompeii Beethoven's Fifth Symphony is played for the first time
James Madison becomes President of the United States Embargo Act of 1807 repealed	Metternich becomes chief minister of Austria Napoleon annexes Papal States
	George III of Great Britain is declared insane; the Prince of Wales becomes Prince Regent Jane Austen publishes *Sense and Sensibility*
War of 1812 begins Louisiana becomes a state	Napoleon invades Russia Lord Elgin brings the Elgin Marbles to England from Greece
Battles of Lake Erie and the Thames fought in War of 1812 Creek War begins	Napoleon is defeated in the Battle of Nations Austria and Prussia declare war on France Jane Austen publishes *Pride and Prejudice*
Creek War ends British burn and sack Washington, D.C. in War of 1812 Francis Scott Key writes "Defense of Fort McHenry," which becomes "The Star-Spangled Banner"	Napoleon is exiled to Elba Louis XVIII accedes to the French throne Congress of Vienna begins Ingres paints *L'Odalisque*
War of 1812 ends	Napoleon is defeated at Waterloo and is exiled to St. Helena Corn Law is passed in Great Britain Congress of Vienna ends
Indiana becomes a state Congress charters Second Bank of the United States	Economic crisis hits Great Britain The British Museum buys the Elgin Marbles
James Monroe becomes President of the United States Mississippi becomes a state	
Illinois becomes a state	El Prado Museum is founded in Madrid
Economic Panic of 1819 Alabama becomes a state	Theodore Gericault paints *The Raft of the Medusa*
Missouri Compromise Maine becomes a state	Sir Walter Scott publishes *Ivanhoe*
Missouri becomes a state First high school in the United States opens in Boston	Napoleon dies in exile Prince Regent of Great Britain is crowned George IV John Constable paints *The Hay Wain*
Gaslights are installed to light Boston streets	Congress of Verona begins Daguerre and Bouton invent the diorama

Chronology

	William Sidney Mount and His Family	New York/*New York City
1823		*The *New York Mirror* begins publication
1824	Mount becomes an apprentice to his brother Henry in New York City	*Micah Hawkins' *The Saw Mill* opens at Wallack's Chatham Square Theatre Micah Hawkins' "Massa Georgee Washington and General La Fayette" is performed in honor of "the Nation's guest"
1825	Micah Hawkins dies in New York City	*Celebration for the official opening of the Erie Canal *New York Drawing Association (later the National Academy of Design) is founded *Independent Band of New York City is founded
1826	Mount starts to attend classes at The National Academy of Design	
1827	Mount ends his apprenticeship with Henry; returns to Stony Brook	
1828	Mount works in Henry Inman's studio for one week Mount paints *Self Portrait with Flute, Christ Raising the Daughter of Jairus*	
1829	Mount and his brother Shepard go into business as portrait painters in New York City Mount paints *Girl with Pitcher*	*Sketch Club for writers and artists holds its first recorded meeting William M. Davis, Long Island painter, is born
1830	Mount paints *Rustic Dance After a Sleigh Ride, Portrait of Bishop Benjamin Tredwell Onderdonk, School Boys Quarreling*	*Organizational meetings for the founding of New York University Charles Seabury patents his Piano Forte Action
1831	Mount paints *Dancing on the Barn Floor, Portrait of Henry Smith Mount*	Uri Corelli Hill, leading American violinist, leads New York Sacred Music Society in full-scale performance of Handel's *Messiah* *Horse-drawn buses first appear in New York City
1832	Mount paints *Portrait of Reuben Merrill, Costume Sketch*	*Democratic Party sweeps fall elections *New York and Harlem Railroad, the first New York City railway, begins operation
1833	Mount paints from casts at the American Academy of Fine Arts Mount paints *Portrait of Mrs. Timothy Starr, Long Island Farmer Husking Corn* (which he records painting out of doors)	*Journeyman tailors go on strike *The Knickerbocker* begins publication
1834	Mount travels to Athens, Pennsylvania; Ithaca, New York; the Catskill Mountains, where he visits Thomas Cole Mount's paintings first reproduced as popular prints	*William Dunlap publishes *A History of the Rise and Progress of the Arts of Design,* includes William Sidney Mount
1835	Mount paints *Bargaining For a Horse, Truant Gamblers, The Volunteer Fireman, The Sportsman's Last Visit* Mount meets Luman Reed	*The first major New York City fire destroys more than 700 buildings *New York *Herald* begins publication
1836	Mount paints *Farmers Nooning* Mount travels to Philadelphia, where he meets Thomas Sully, Thomas Birch, Alexander Lawson, and sees several pictures by John Lewis Krimmel	*Allen Dodworth establishes Dodworth's Band, the best brass band in the city until late in the century Long Island Railroad begins operation
1837	Mount paints *Portrait of Jedediah Williamson, Raffling for the Goose, The Long Story*	*N.Y. banks suspend specie payments, signal first true financial depression *Samuel F.B. Morse exhibits his electric telegraph *Uri Corelli Hill returns to the city to teach and to conduct
1838	Mount paints *Dregs in the Cup (Fortune Telling), The Painter's Triumph*	*New York *Morning Herald* becomes the first U.S. newspaper to hire European correspondents Walt Whitman begins publication of the *Long Islander* in Huntington

United States	Europe
Monroe Doctrine	French forces restore Ferdinand VII to absolute power in Spain
James Bridges discovers the Great Salt Lake Marquis de Lafayette tours the United States	National Gallery is founded in London Eugene Delacroix paints *Les Massacres de Chios*
John Quincy Adams becomes President of the United States Robert Owen founds the utopian community of New Harmony, Indiana	Nicholas I becomes Czar of Russia; he suppresses the Decembrist Revolt
American Temperance Society is founded in Boston James Fenimore Cooper publishes *The Last of the Mohicans*	
Deming Jarves introduces Sandwich glass in Sandwich, Massachusetts Charles Willson Peale dies	Beethoven dies
Construction on Baltimore and Ohio Railroad begins Noah Webster publishes the *American Dictionary of the English Language*	Russia declares war on Turkey
Andrew Jackson becomes President of the United States James Smithson bequeaths funds to establish the Smithsonian Institution William Burt is granted the first U.S. patent for a typewriter	Chopin debuts in Vienna
William Sublette leads first covered wagon train from the Missouri River to the Rocky Mountains Joseph Smith organizes the Church of Jesus Christ of the Latter-Day Saints	Louis Philippe accedes to the throne of France William IV accedes to the throne of Great Britain and Ireland Revolt breaks out in Paris
Nat Turner leads slave revolt, the Southampton Insurrection, in Virginia Mount Auburn, the first "rural cemetery," opens in Boston	
Black Hawk War begins and ends Democratic Republican Party becomes the Democratic Party New England Anti-Slavery Society is founded in Boston	
"Jim Crow" song and dance act plays at the City Theatre, Louisville, Ky. Oberlin College, first co-educational college in the U.S., is founded	Great Britain officially abolishes slavery in the British Empire
Whig Party formed Cyrus Hall McCormick patents his reaper	British government passes the Poor Law which establishes workhouses for the able-bodied poor Marquis de Lafayette dies
Seminole War begins Halley's Comet reappears Samuel Colt patents a revolving-breech pistol	Ferdinand I becomes Emperor of Austria
Arkansas becomes a state Siege and Battle of the Alamo New England writers and artists form the Transcendental Club	
Martin Van Buren becomes President of the United States Economic Panic of 1837 Michigan becomes a state The first college for women is founded in Mount Holyoke, Massachusetts	Victoria is crowned Queen of Great Britain
Federal troops remove the Cherokee from Georgia on the "Trail of Tears"	The first transatlantic crossing by ships entirely powered by steam is made National Gallery opens in London

Chronology

	William Sidney Mount and His Family	New York/*New York City
1839	Mount travels to Boston, where he meets Washington Allston, George Flagg, Francis Edmonds Mount paints *Catching Rabbits*	*Apollo Association (later the American Art-Union) is founded *New York and Harlem Railroad introduces steam engines on its line Abner Doubleday conducts the first baseball game in Cooperstown
1840	Mount draws *The Setauket Military Band*	Long Island's whaling industry begins a period of prosperity Paddlewheel steamship *Lexington* burns and sinks in Long Island Sound
1841	Mount draws *Portrait of Julia Ann Hawkins Mount,* paints *Cider Making* Julia Ann Hawkins Mount dies Henry Smith Mount dies	*Horace Greeley founds the *New York Tribune* *P.T. Barnum opens the American Museum in New York City Trains begin to run from the East River to Greenport, Long Island
1842	Mount paints *Ringing the Pig*	*John Jacob Astor plans to endow a library for the public which later becomes New York Public Library *N.Y. Philharmonic Orchestra's first concert (Uri C. Hill principal founder) *P.T. Barnum exhibits Tom Thumb
1843	Mount travels to Hartford, Connecticut; Albany, New York; the Catskill Mountains Apollo Association publishes engraving after Mount's *Farmers Nooning* for its members	*Dan Emmett, composer of "Dixie," and his associates launch the Virginia Minstrels, first *organized* minstrel show in the city *Ole Bull, renowned Norwegian concert violinist, makes first of five visits to the U.S.
1844	Mount paints *The Trap Sprung, The Trying Hour*	The first trip running the full length of the Long Island Railroad is completed, reaches Suffolk County B.F. White and E.J. King publish the first edition of *The Sacred Harp,* an important anthology of folk hymns
1845	Mount draws sketch for *Dance of the Haymakers* and *The Power of Music* Mount paints *Dance of the Haymakers, Eel Spearing at Setauket*	
1846		*Grace Church is consecrated, marks near completion of first luxury area in the city Edward Lange, Long Island painter, is born
1847	Mount paints *The Power of Music, Spring Bouquet, Loss and Gain* Goupil, Vibert & Company sends William Schaus to New York, where he meets Mount	The New York Academy of Medicine is founded *The Literary World* begins publication
1848	Mount draws *Waiting for the Tide,* paints *Farmer Whetting His Scythe* Goupil, Vibert & Company publishes lithograph after Mount's *The Power of Music*	The first Woman's Rights Convention is held in Seneca Falls Oneida Community, a utopian community, is founded
1849	Mount paints *Just in Tune;* draws *Headstrong* series Goupil, Vibert & Company publishes lithograph *Music is Contagious* after Mount's *Dance of the Haymakers*	*Astor Place Riots, city is effectively placed under martial law for the first time
1850	Mount paints *California News, Right and Left, The Mill at Stony Brook* Goupil & Co. publishes lithograph *Catching Rabbits* after Mount's *Boys Trapping* and lithograph after Mount's *Just in Tune*	*Jenny Lind arrives in the city, the celebration for her arrival sets the standard for future celebrations, P.T. Barnum sponsors her concert tour of the U.S. *Harper's Monthly* begins publication
1851	Mount paints *Crane Neck Across the Marsh* American Art-Union publishes engraving after Mount's *Bargaining For a Horse* Goupil & Co. publishes lithograph after Mount's *The Lucky Throw*	*The *New York Daily Times* is founded, later the *New York Times*
1852	Mount patents the "Cradle of Harmony" Mount records his idea for an "Artist waggon," or portable studio Goupil & Co. publishes lithograph after Mount's *Right and Left*	
1853	Mount paints *The* Herald *in the Country*	*Various models of Mount's "Cradle of Harmony" are displayed at the Exhibition of Industry of All Nations in N.Y.'s Crystal Palace Henry Steinway [Heinrich Steinweg] begins to manufacture pianos
1854	Mount paints *The Mount House, Coming to the Point, Long Island Farmhouses* Goupil & Co. publishes lithograph after Mount's *The* Herald *in the Country*	*New York Academy of Music opens

United States	Europe
Aroostoock War Charles Goodyear discovers the vulcanization process Erastus Bigelow devises power loom that weaves 2-ply ingrain-carpets Samuel F.B. Morse produces the first daguerreotype portraits in the U.S.	Daguerre perfects the daguerreotype process Kirkpatrick Macmillan, a Scot, builds the first bicycle
Washington Temperance Society formed James Fenimore Cooper's *The Pathfinder* is a best seller	Queen Victoria marries Prince Albert
President Harrison dies, John Tyler becomes President of the United States John Bidwell leads first settlers overland from Kansas to California Edgar Allan Poe publishes "The Murders in the Rue Morgue" Catherine Beecher publishes *A Treatise on Domestic Economy*	Sir David Wilkie dies
Seminole War ends Elijah White leads first large group of settlers to the Oregon Territory Massachusetts Legislature limits child labor to ten hours per day Georgia physician C.W. Long discovers anaesthetic property of ether	Charles Dickens publishes *A Christmas Carol*
Congress grants Samuel F.B. Morse money to build first telegraph line John C. Fremont crosses Rocky Mountains to explore Oregon, Nevada and California Elias Howe invents the Howe Sewing Machine	
Samuel F.B. Morse sends first telegraph message from Washington, D.C. to Baltimore	German engineer Gottlob Keller invents a process for the production of paper from wood pulp
James Knox Polk becomes President of the United States Texas and Florida become states Erastus Bigelow invents the Brussels power loom to make carpets U.S. Naval Academy opens in Annapolis, Maryland	Alexandre Dumas publishes *The Count of Monte Cristo*
Mexican War begins Iowa becomes a state; Black Bear Revolt claims California for U.S. Brigham Young leads Mormons to the Great Salt Lake Smithsonian Institution founded	Ireland's potato crop fails and famine sweeps the country
First adhesive postage stamps go on sale	Charlotte Brontë publishes *Jane Eyre*
Mexican War ends Wisconsin becomes a state Marshall discovers gold at Sutter's Mill in California Spiritualism becomes popular in the U.S.	Revolts in Paris, Vienna, Berlin, Milan, Rome and Parma Karl Marx and Friedrich Engels write the *Communist Manifesto* Hunt, Millais and Ròsetti found the Pre-Raphaelite Brotherhood
Zachary Taylor becomes President of the United States Gold Rush in California Walter Hunt patents the safety pin	French physicist Armand Fizeau measures the speed of light Charles Dickens publishes *David Copperfield*
Millard Fillmore becomes President of the United States Compromise of 1850 California becomes a state Nathaniel Hawthorne publishes *The Scarlet Letter*	Joseph Paxton builds the Crystal Palace in London Gustave Courbet paints *The Stonebreakers*
Emmanuel Leutze paints *Washington Crossing the Delaware* Herman Melville publishes *Moby Dick*	France's Third Republic ends London's Great Exhibition features the Corliss steam engine English architect Scott Archer develops the wet collodion process for photography
Elisha Graves Otis invents the safety elevator Harriet Beecher Stowe publishes *Uncle Tom's Cabin* Wells, Fargo and Co. is founded	Louis Napoleon accedes to the French throne as Napoleon III
Franklin Pierce becomes President of the United States	
Republican Party formed New England Emigrant Aid Society opens Henry David Thoreau publishes *Walden, or Life in the Woods*	Crimean War begins

Chronology

	William Sidney Mount and His Family	New York/*New York City
1855	William Schaus publishes lithograph after Mount's *Coming to the Point*	Effingham Tuthill opens his carriage-maker's shop in Port Jefferson, L.I.
1856	Mount paints *The Banjo Player*, *The Bone Player*	*Harper's Weekly* begins publication
1857	Thomas Seabury builds one version of the "Cradle of Harmony" W. Alfred Jones publishes *Characters and Criticism* Wm. Schaus publishes lithographs after Mount's *The Banjo Player* and *The Bone Player*	Financial panic hits New York *Frederick Law Olmstead is appointed superintendent of New York City's Central Park
1858		*Central Park opens to the public
1859		
1860	Mount draws *Slaughtering Hogs*	Nunns begins construction of piano factory in Setauket, Long Island
1861	Effingham Tuthill builds Mount's portable studio	Vassar College chartered
1862	Mount writes letter to Samuel Seabury on artists' materials	*A.T. Stewart has the world's largest department store built in New York City
1863		*Draft riot in New York City
1864		*Confederate agents burn the Barnum Museum and Astor House in their effort to burn the city *Stephen Foster dies at Bellevue Hospital in New York City
1865	Mount paints *Catching Crabs*, *Fair Exchange No Robbery*	
1866	Mount paints *Catching the Tune*	*Steinway Hall opens in New York City
1867	Mount paints *The Dawn of Day (Politically Dead)* Mount draws *Portrait of Midshipman Seabury*	*Allen, Ware and Garrison publish their *Slave Songs of the United States*, the first collection of Negro spirituals
1868	Shepard Alonzo Mount dies William Sidney Mount dies at the home of Robert Nelson Mount in Setauket	

United States	Europe
Henry Wadsworth Longfellow publishes *Song of Hiawatha* Walt Whitman publishes *Leaves of Grass*	Alexander II succeeds Nicholas I as Czar of Russia English chemist Alexander Parkes patents celluloid Paris International Exposition The Louvre opens in Paris
Western Union Telegraph Company formed	Crimean War ends
James Buchanan becomes President of the United States Dred Scott decision Currier and Ives issue their first prints	Giuseppe Garibaldi forms Italian National Association for Unification Gustave Flaubert publishes *Madame Bovary* Victoria and Albert Museum opens
Minnesota becomes a state Lincoln-Douglas debates Elias Howe's *Complete Ballroom Handbook* is published in Boston John Landis Mason patents the Mason Jar	Alexander II emancipates serfs in Russia
Oregon becomes a state John Brown leads raid on Harpers Ferry, Virginia First oil well is drilled in Titusville, Pennsylvania	France declares war on Austria German National Association is founded Charles Dickens publishes *A Tale of Two Cities* Charles Darwin publishes *On the Origin of Species . . .*
First Winchester repeating rifle produced in New Haven, Connecticut First Pony Express rider leaves St. Joseph, Missouri for California	Giuseppe Garibaldi's Red Shirts take Naples and Palermo, declare Victor Emmanuel King of Italy Jean Ettienne Lenoir patents an internal combustion engine
Abraham Lincoln becomes President of the United States Civil War begins Congress levies the first U.S. income tax Kansas becomes a state	Italy becomes a single united kingdom
Battles of Shiloh, Antietam and Second Battle of Bull Run Homestead Act Morrill Land Grant Act provides funds to start U.S. land grant colleges Elias Howe's *American Dancing Master* is published in Boston	Otto Von Bismarck is appointed premier of Prussia
Emancipation Proclamation issued Abraham Lincoln makes Gettysburg Address West Virginia becomes a state and joins the Union National Academy of Sciences founded in Washington, D.C.	First underground railroad opens in London Salon des Refusés opens in Paris for paintings rejected by The French Academy
Nevada becomes a state General Sherman begins his "March to the Sea" through Georgia George Pullman and Ben Field patent a railway sleeping car California's Yosemite Valley becomes first U.S. national scenic preserve	The Red Cross is established by the Geneva Convention Edouard Manet paints *The Dead Toreador*
Abraham Lincoln assassinated; Andrew Johnson becomes President Civil War ends Thirteenth Amendment abolishes slavery; Ku Klux Klan formed Yale University opens first Department of Fine Arts in the U.S.	Gregor Mendel presents a paper to the Brunn Society for the Study of Natural Science on natural laws of heredity Lewis Carroll publishes *Alice's Adventures in Wonderland*
Reconstruction begins in the South The American Equal Rights Association is founded First oil pipeline constructed in Pennsylvania	War between Austria and the Prussian-Italian alliance begins and ends Alfred Nobel invents dynamite Count Leo Tolstoy publishes the first part of *War and Peace*
The U.S. buys Alaska from the Russians; Nebraska becomes a state Horatio Alger publishes a serialized version of *Ragged Dick, or Street Life in New York* Impeachment trial held for President Andrew Johnson; he stays in office	Giuseppe Garibaldi is taken prisoner after the "March on Rome" Paris World's Fair
Seven former confederate states readmitted to the Union First professional baseball club, Cincinnati Red Stockings, is founded Louisa May Alcott publishes *Little Women*	Revolution in Spain Archaeologist Edouard Lartet discovers Cro-Magnon man of the Upper Paleolithic period in a French cave

William Sidney Mount

Works in the Collection of The Museums at Stony Brook

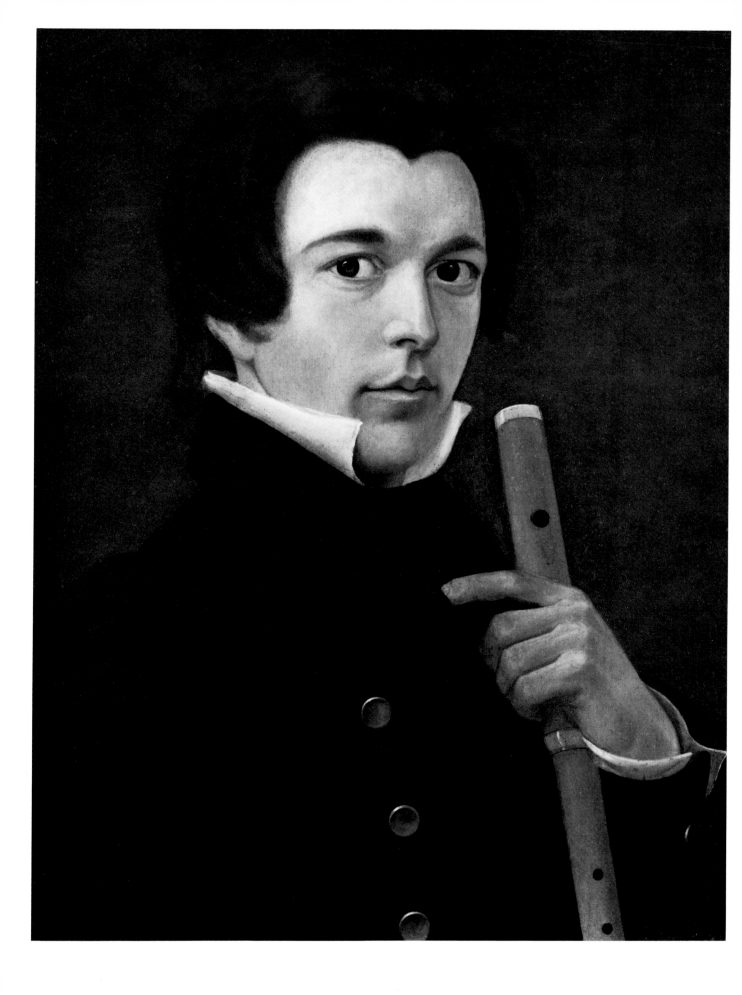

Self Portrait with Flute 1828
Oil on panel
50.8 × 40.3 (20 × 15⅞)
Inscription: (on reverse) *My first likeness/ Portrait of Wm. S. Mount/By Himself/ 1828*
Gift of Mr. and Mrs. Ward Melville, 1958

"Catalogue of portraits and pictures painted by William Sidney Mount"
1839–1857
Ink on paper
19.7 × 16.2 (7¾ × 6⅜)
Bequest of Ward Melville, 1977

This panel painting represents William Sidney Mount's formal debut as a portrait painter. The reverse of the panel bears the inscription "My first likeness/Portrait of Wm. S. Mount/By Himself/1828." When he looked back on his career years later, Mount wrote in his "Catalogue of portraits and pictures painted by William Sidney Mount":

> In the year 1825 I commenced drawing with lead pencil and sometimes with white chalk, on a blackboard—in my Brother's paint shop. . . . When I had a leasure moment. . . .
> In the spring of 1828 at Stony Brook I believe painted with colors a girl at a spring reading a love letter. . . . A portrait of myself in 1828.[1]

William attended classes at the National Academy of Design in New York City (established in 1825) in 1826 and 1827 while he served as an apprentice in his brother Henry's sign painting shop. In the following year William painted this "head and bust life size" in Stony Brook.[2] Although Mount had received some formal artistic training, his tightly controlled linear modeling of the features and his emphasis on the head in this first self portrait resemble the less sophisticated techniques commonly associated with non-academic painters. His tendency to paint within precisely defined forms no doubt reflects the craft tradition of ornamental painting in which he had been trained in his brother's shop. Mount's inclusion of the flute in his painting is doubly significant: it is an object that is an attribute of the sitter, a common portrait motif; and it is an instrument, an early example of the confluence of art and music in Mount's compositions.

1 William Sidney Mount, "Catalogue of portraits and pictures painted by William Sidney Mount," 1839–1857, 3, ms, The Museums at Stony Brook.
2 William Sidney Mount, autobiographical notes, Jan. 1854, 2, ms, The Museums at Stony Brook.

Christ Raising the Daughter of Jairus
 1828
Oil on panel
46.1 × 61.6 (18⅛ × 24⅜)
Inscription: (lower left) *W.S.M./N.A./1828*
Gift of Mr. and Mrs. Ward Melville, 1958

Detail, **Anatomical Studies** 1826
Pencil on paper
16.6 × 9.2 (6⁹⁄₁₆ × 3⅝)
Inscription: (lower left) *Wm. S. Mount
 1826*
Gift of the Estate of Ruth S. Kidder; Mrs.
 Mary Rackliffe; Miss Edith Douglass; Mr.
 Andrew E. Douglass; in memory of Mrs.
 Moses Douglass and Mrs. Scott (Ruth
 S.) Kidder, 1956

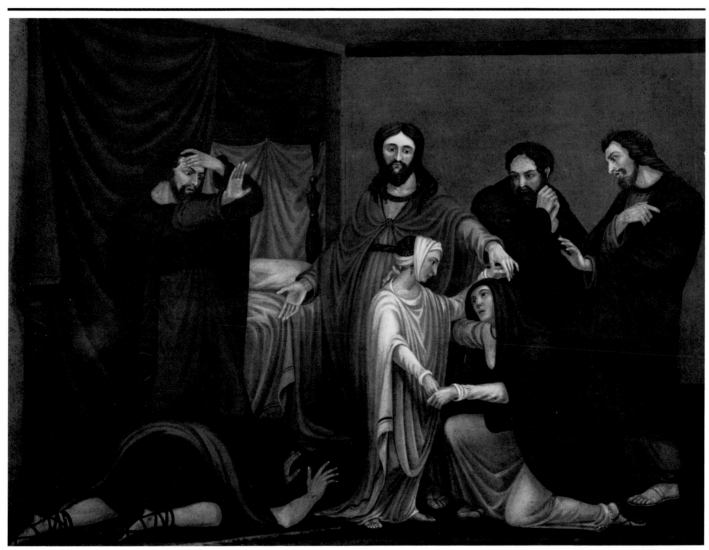

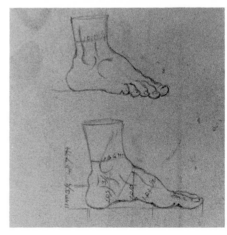

36

Study for Christ Raising the Daughter of Jairus 1828
Ink on paper
20.3 × 33.0 (8 × 13)
Inscription: (lower right) *Wm. S. Mount 1828*
Bequest of Ward Melville, 1977

The late eighteenth century discoveries of Herculaneum and Pompeii inspired a revival of European interest in classical antiquity that manifested itself in European art. In the early nineteenth century a number of prominent European-trained American artists attempted to import the continental tradition of incorporating Greek and Roman prototypes in artistic composition into the United States. This artistic style, generated in Europe, was known as the "grand manner," and was emphasized in American drawing classes. It was also promulgated in such lecture series as that given in 1828 by William Cullen Bryant, one of the foremost American poets and journalists, on the subject of Greek and Roman mythology.[1]

William Sidney Mount described his own classical studies as follows: "I drew from the Antique models at the academy evenings—and during the day time when not engaged in lettering signs—."[2] He noted in his "Catalogue of portraits and pictures . . ." that, in 1828, "Reading ancient history took much of my time."[3] His sketch of a foot (illustrated here) dated 1826, is an example of an academic anatomical study from a cast of an antique sculpture.

Christ Raising the Daughter of Jairus (1828) was Mount's first history painting. This portrayal of a stirring scene from the New Testament is his rather awkward attempt to embrace the lofty tradition of painting historical subjects. It is thought that the figures' frozen gestures are based on such impassioned poses as those assumed by the figures in Benjamin West's well-known work, *Christ Healing the Sick in the Temple* (1815, Pennsylvania Hospital, Philadelphia).[4] Both Mount's use of rich primary colors and his attempt to capture the scene's expressive potential are characteristic of paintings executed in the "grand manner." The coiled pattern of the girl's hair and the flattened folds of the figures' robes (both of which add decorative effect to the composition rather than define the bodies beneath them) suggest that this work was done in a formative stage of the artist's career. It has been pointed out that in this painting Mount:

displays correct neoclassical costumes but the twenty-one-year-old beginner failed to get completely off the gound. For the sickbed from which Jairus's daughter had just risen, Mount delineated such an ordinary four-poster as that in which he himself slept.[5]

Christ Raising the Daughter of Jairus appeared in the National Academy of Design's 1828 exhibition "by the earnest request" of the artist's brother Henry.[6]

In striking contrast to the rigid lines of the finished oil painting, the pen strokes of the preliminary study possess an energy that indicates Mount's early potential as a master draftsman. The few slashing lines that delineate the figure in the lower left foreground express the intensity of the emotion he feels as he witnesses the awesome miracle. The overall sense of joy and amazement that the artist depicted in these few lines aroused the attention of Samuel F. B. Morse, President of the National Academy. As Mount recorded in his autobiographical notes in 1854, Morse:

remarked he had never seen any design like it, and expressed himself pleased with it, and further said, as regards [respects] design, he had not seen its equal amongst any of the modern masters, & that succeeding pictures would test originality, both execution & design—[7]

1 James T. Callow, *Kindred Spirits: Knickerbocker Writers and American Artists, 1807–1855* (Chapel Hill, N.C.: The University of North Carolina Press, 1967), 31.
2 Mount, autobiographical notes, Jan. 1854, 2.
3 Mount, "Catalogue of portraits and pictures . . . ," 3.
4 [Mary] Bartlett Cowdrey and Hermann Warner Williams, Jr., *William Sidney Mount, 1807–1868: An American Painter* (New York: Columbia University Press, 1944), 3.
5 James Thomas Flexner, *That Wilder Image: The Painting of America's Native School from Thomas Cole to Winslow Homer* (Boston: Little, Brown and Company, 1962), 29–30.
6 Mount, autobiographical notes, Jan. 1854, 2.
7 Mount, autobiographical notes, Jan. 1854, 2. It is interesting to note the inscription on this painting. Although Mount did not become a National Academician until 1832, it is possible that he added "N.A." to this painting's inscription after that date.

Girl with Pitcher 1829
Oil on canvas
52.2 × 40.5 (20¾ × 16)
Inscription: (lower left) *William S. Mount./1829*
Gift of Mrs. F. Henry Berlin, 1979

ount described this painting as "Girl with a pitcher standing at a well" in an 1829 entry in his "Catalogue of portraits and pictures. . . ." In this work, as in the lost painting "Girl at the spring reading a love letter" (1828), Mount depicts a sentimental outdoor scene. Comparison of this painting to the two preceding paintings reveals some diversity in the artist's style and suggests that he experimented with various subjects as he developed his technique. Here he has exchanged the linear pattern and harsh color of *Christ Raising the Daughter of Jairus* for freer brush strokes and subtle earth tones, both of which are evident in the willow branch leaves in *Girl with Pitcher*.

This painting suggests that Mount began to rely on his immediate surroundings for detail in his paintings: just as he depicted a common (and perhaps familiar) bedstead in a classical setting, so he included his family's home in this sentimental rural scene. The door handle in the painting still latches the door of the north kitchen wing of the Hawkins-Mount House. The painting also documents the existence of a beehive section of the oven which was unrecorded prior to The Museums acquisition of this painting in 1979.

This painting was exhibited in the National Academy of Design's 1830 exhibition next to the artist's first critically acclaimed genre painting, *Rustic Dance After a Sleigh Ride* (1830, illustrated p. 17). A critic who was the artist's contemporary offered the following reason for Mount's departure from painting historical subjects: "[he] understood that it was better to be a good descriptive painter than a common painter of history. . . ."[1] In the autobiographical notes he wrote in 1854, Mount included an 1830 notice from the National Academy of Design that stated: "Mr. Mount's picture of the dance taken from the popular story of the 'Sleigh Ride,' exhibits powers of no ordinary kind, which with his Girl & Pitcher, a picture true to nature, gives earnest of future excellence—."[2] Mount recorded that he sold this painting for $8.00.[3] In a letter to his brother Robert Nelson Mount, dated May 29, 1830, the artist not only explained that he had sold his "Cottage," but repeated the following anecdotal description and advice from an unidentified critic who reviewed the 1830 exhibition at the National Academy:

> Mount's little girl from Cottage comes;
> In natur's tints she lovely blooms,
> Whilst o'er her head the willow tree,
> Waves as it should so droopingly.
> ·
> Take nature for a guide, and she
> Will show what wants variety.
> Study good composition well
> One day in this thou may'st excel.
>
> In harmony more thy collors blend,
> I speak as't were to any friend,
> Who leaves them, now in hopes to se
> Still better things next year from the.[4]

1 Th[eodore] Lacombe, "American Artists: Wm. S. Mount," *The Home Journal*, 20 Dec. 1851, 1, col. 6.
2 Mount, autobiographical notes, Jan. 1854, 4.
3 Mount, "Catalogue of portraits and pictures . . . ," 4.
4 William Sidney Mount, Letter to Robert Nelson Mount, 29 May 1830, ms, Collection of Theodore E. Stebbins, Jr. Printed courtesy of Theodore E. Stebbins, Jr.

Girl with Pitcher (1829, The Museums at Stony Brook, illustrated p. 38) represents William Sidney Mount's first departure from painting portraits and history paintings. In 1830 he painted his first fully developed genre paintings—multiple figure compositions depicting everyday scenes. Three such Mount paintings are recorded for the year 1830: *Rustic Dance After a Sleigh Ride* (Museum of Fine Arts, Boston, illustrated p. 17), *Scene in a Cottage Yard* (location unknown) and *School Boys Quarreling*.[1] Like *Rustic Dance After a Sleigh Ride*, which is almost certainly based on John Lewis Krimmel's painting *Country Frolic and Dance* (date and present location unknown), Mount's *School Boys Quarreling* seems to depend on the work of other artists. The balanced composition of his carefully arranged figures is much more suggestive of neo-classical paintings such as Jacques-Louis David's celebrated *Oath of the Horatii* (1784, Musée du Louvre, Paris) than of a schoolboy melee.

Unfortunately, Mount did not record which artists' works inspired his composition for *School Boys Quarreling*. For the architectural setting of the painting, Mount looked to his immediate surroundings—much as he had done for *Girl with Pitcher*—as he recorded in his journal, "School Boys quarreling. year 1830—the shed was partly painted out of doors. figures in doors—."[2] *School Boys Quarreling* seems to be the first painting of which Mount painted a portion outdoors, and the foregoing note, the first time he recorded such an activity.

Mount wrote that he had completed entire paintings in the open air by 1833, when he painted *Long Island Farmer Husking Corn* (The Museums at Stony Brook, illustrated p. 50).

In 1831 *School Boys Quarreling* was exhibited at the National Academy of Design under the title *Boys Quarreling After School*; in later exhibitions it bore the title *Take One of Your Size*. A critic for the *New York Mirror* wrote, "A humorous delineation, and eminently successful."[3]

However Mount's paintings were received by the press, their innovative subject matter soon began to influence other artists. Mount wrote that, "George W. Flagg Esqr. mentioned to the artist [Mount] that on seeing the above picture he was induced to become a painter—."[4] Traces of the composition of *School Boys Quarreling* can be detected in the works of other American genre painters later in the nineteenth century.[5]

In 1832 Mount sold *School Boys Quarreling* to Pierre Flanden for $50.00. Flanden is known to have exhibited and sold works by German-born Philadelphia genre painter John Lewis Krimmel in New York City. The subsequent history of ownership of *School Boys Quarreling* is also interesting. By 1858, the painting had passed into the Philadelphia collection of Caleb Jones. Jones's collection was sold at auction in 1858, and *School Boys Quarreling* was purchased by the famous actor Edwin Forrest. Mount's friend John M. Falconer attended the sale, as he wrote to the artist on June 28:

My dear Sir
I saw in Philadelphia a few days ago part of your family one of your children, altho in the party was 6 children, partaking of or delighting in a *muss* which your flock generally has not done. What I saw and was much pleased with was your *"Take one of Your Size,"* a work of yours that I had never seen before either on canvass or engraved. I was instrumental at an auction where it was offered, in helping to bid it up which I did as far as $150 but after that longer purses were of more avail and at 165$, Edwin Forrest became its purchaser as he also did, a work of Leutzes—Your picture was dated & signed 1830 was in good sound condition & order & color generally in full freshness altho the thinnest paints had darkened most. The lettering on the book is as distinct & clear as if it were yesterdays work. & the little *bantam boy* of woeful counte-

nance has his clarets as pure as when you first drew it off your palette—It was in the collection of a Mr Jones who had met with bad luck & whose house & household gods had to pass under the red flag of St. Peters.

You doubtless remember the work and it ocurred to me that a slight recall of it might be pleasant for you as there would doubtless be stored away in memory random facts of interest that were connected with it when produced & which lapse of time & new interests had almost given the go-by to.[6]

Later *School Boys Quarreling* was part of the collection of Robert W. Weir, historical painter and drawing instructor at West Point, and father of artists John Ferguson Weir and Julian Alden Weir. Weir's collection was sold at auction in 1891, and *School Boys Quarreling* passed unrecorded into private collections. This painting, which represents an important stage in Mount's development as an artist, was rediscovered in 1982 and acquired by The Museums at Stony Brook in 1983. It is reproduced here for the first time.

1 William Sidney Mount exhibited a painting entitled *Scene in a Cottage Yard* in the 1831 exhibition of the National Academy of Design (no. 59). In his own catalog of paintings, he listed "Landscape with Children at Play" (1830, location unknown). These two titles may refer to the same painting. On the other hand, Mount and others referred to *Girl with Pitcher* (1829, The Museums at Stony Brook, illustrated p. 38) as his "cottage" picture. It was only after 1831 that the National Academy limited submissions for its annual exhibitions to works not previously exhibited; therefore, *Scene in a Cottage Yard* actually may refer to *Girl with Pitcher*.
2 Mount, Diary/Journal 1848–1857, 122.
3 *The New York Mirror: A Weekly Journal Devoted to Literature and the Fine Arts*, 7 May 1831, 350, as quoted in Cowdrey and Williams, 14.
4 Mount, autobiographical notes, Jan. 1854, 4.
5 An anonymous American painting in The Museums at Stony Brook's collection echoes the composition of *School Boys Quarreling*, and even includes an old woman peering out of a double door. Of course both Mount and the anonymous artist may have been inspired by a third, unidentified work.
6 John M. Falconer, Letter to William Sidney Mount, 28 Jun. 1858, ms, The Museums at Stony Brook.

School Boys Quarreling 1830
Oil on canvas
50.7 × 62.7 (20 × 24¾)
Inscription: (lower right) *Wm. S. Mount*
 1830; (on reverse) *PAINTED/By,/Wm. S.*
 Mount,/1830.
Museums Collection, Purchase made pos-
 sible by earlier gift of Mr. and Mrs. Ward
 Melville
Photo by George Roos

The critics who praised Mount's works in the National Academy of Design's 1830 exhibition commented that they eagerly awaited his next canvases. When Mount painted *Dancing on the Barn Floor* two years after *Girl with Pitcher* (1829), he proved the critics' earlier enthusiasm to be justified. In the later painting he shows his mastery of technique in his depiction of the human body and its movement. The girl merrily swings her lifted skirt, the folds of which clearly define her body. The young man's expression of cheerful anticipation beckons the viewer to join in the dance. The contrast between the intricate graining on the barn walls in this painting and the mere suggestion of graining on the porch boards in *Girl with Pitcher* demonstrates the degree to which Mount used brushwork to delineate even minute details that he perceived in his surroundings. In *Dancing on the Barn Floor* Mount confronted the problem of the definition of space and depth, particularly in the barn's interior. His artistic solution to the problem was to arrange groups of figures to describe an interior space, as is evident in this work. Mount would make repeated use of this solution in later compositions.

This painting was exhibited in the National Academy of Design's 1832 exhibition. An unidentified critic praised the artist and his work:

> We have been struck with admiration in contemplating this beautiful picture, and if the artist will adhere to the path which nature has plainly pointed out for him, he will become, the future *Wilkie* of America. . . . The expression, air, and action of the figures is given with irresistible humor.[1]

This critic identified qualities in Mount's work that would be associated with it in criticism he attracted throughout his career. Critics often compared Mount's work to that of Sir David Wilkie (1785–1841), the Scottish artist whose genre paintings were widely known in the United States through engravings. Moreover critics rarely missed an opportunity to comment on the humorous aspect of Mount's work.

A number of years following Mount's execution of *Dancing on the Barn Floor* an exhibition in which it hung with a number of the artist's well-known works prompted an unidentified reviewer to write:

> Mount is *his own author*, he paints what he sees; his scenes are American. The Bargainers for a horse—the dancing on the barn floor— . . . give us scenes and personages we have all seen (or seen something like,) and we are delighted with what had before escaped our observation, or had been forgotten.[2]

Mount's own comments about his painting were more straightforward than those of his critics. Of *Dancing on the Barn Floor* he wrote in his "Catalogue of portraits and pictures . . .": "Interior of a barn. Part of the foreground unfinished—with figures dancing Size of the picture 25 by 30 in Sold in 1835 to James. H. Patterson Esq N.Y. $111—00."[3]

Today this painting is admired both for its artistic merit and for its documentation of rural musical activities in the early nineteenth century. Mount's selection of this subject, one that expresses the delight inspired by lively music and dance, makes his love of music clear. He amassed a large collection of sheet music and eagerly recorded tunes and musicians' variations on them at every opportunity. Although the dance in this painting cannot be specifically identified, current research suggests that a hornpipe would have been appropriate for the impromptu occasion pictured here.[4]

1 "Setauket Scrapbook," Emma S. Clark Memorial Public Library, Setauket, New York, 4. Henceforward this source will simply be listed as "Setauket Scrapbook." Few of the clippings it contains are identified or dated.
2 "Setauket Scrapbook," 5.
3 Mount, "Catalogue of portraits and pictures . . . ," 6.
4 Alan C. Buechner, "Music and Dance in the Paintings of William Sidney Mount," American Musicological Society Paper, Forty-Second Annual Meeting of the American Musicological Society/Nineteenth Annual Meeting of the College Music Society, Washington, D.C., 5 Nov. 1976, 8–9.

Dancing on the Barn Floor 1831
Oil on canvas
62.3 × 75.2 (24⅝ × 29⅝)
Inscription: (lower right) *Wm. S. Mount,*
 pinxt./1831; (on reverse) *Wm. S.*
 Mount/1831
Gift of Mr. and Mrs. Ward Melville, 1955

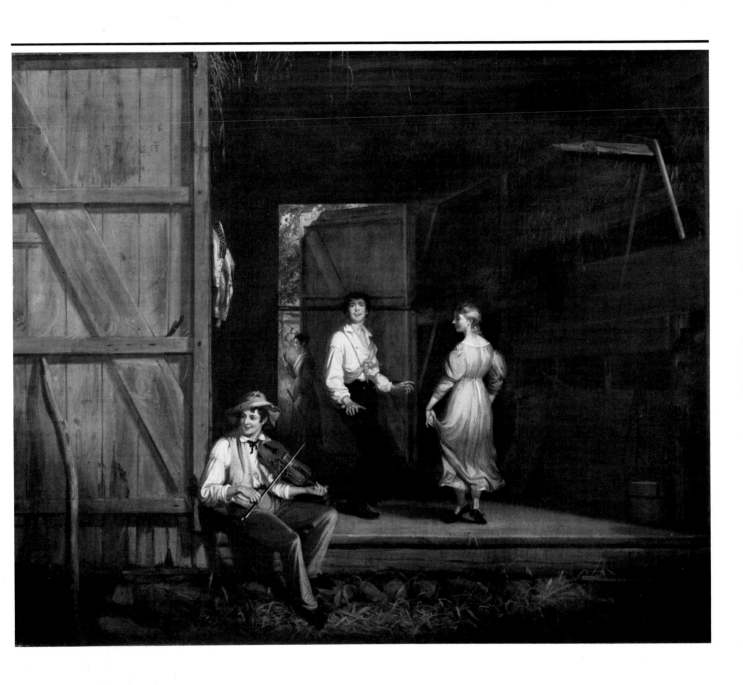

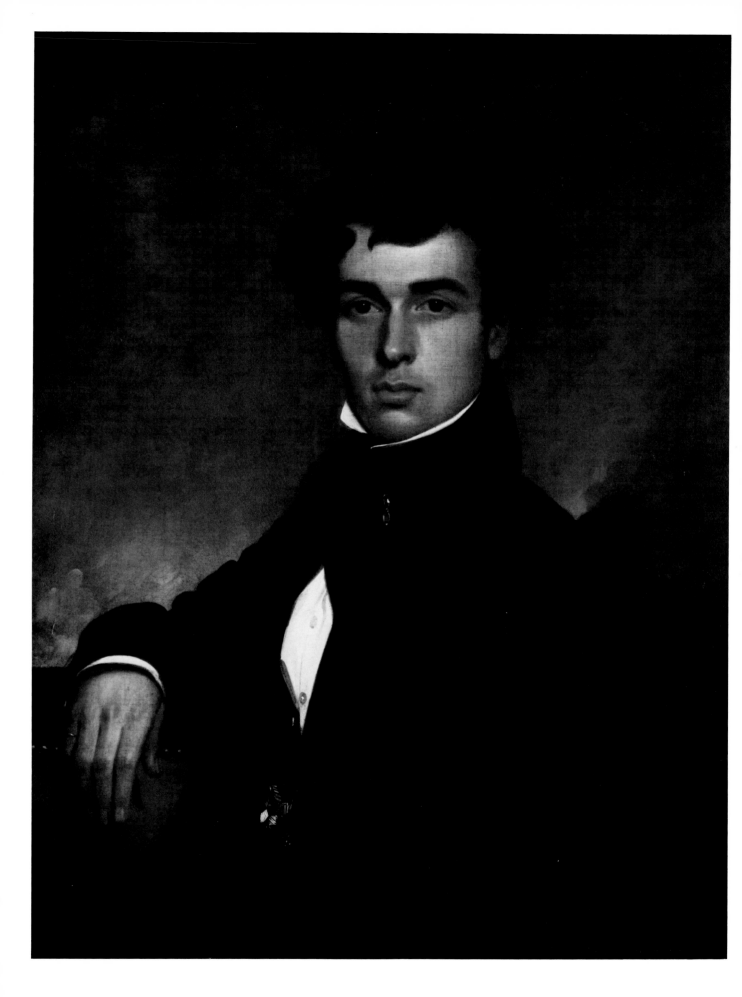

Portrait of Henry Smith Mount 1831
Oil on canvas
88.0 × 69.5 (34½ × 27¼)
Inscription: (on reverse) *Wm. S.
 Mount/1831*
Bequest of Ward Melville, 1977

Palette
Wood
32.0 × 41.9 (12⅝ × 16½)
Inscription: (top left) *H.S. MOUNT/1840*;
 (top right) *Wm.S.MOUNT./July 1847*.
Bequest of Dorothy DeBevoise Mount,
 1959

This 1831 portrait of his eldest brother demonstrates William Sidney Mount's steadily increasing skill as a portraitist. The novice painter whose first portrait, *Self Portrait with Flute* (painted just three years before this one), seems somewhat flat and non-academic, produces in this likeness a rounder, more academic figure that shows the artist's self-assurance and skill in the application of paint and the three-dimensional representation of the human form. The style of this work suggests the influence of Romanticism, an artistic and literary movement whose artists endeavored to produce works in which they were able to evoke a mood and/or to express the personality and the inner thoughts of the characters they portrayed. In this portrait the dashing subject's facial expression suggests deep absorption in thought, and the flash of bright colors in the dark background lends mystery to the figure of the brooding subject.

Henry Smith Mount (1802–1841) took his brother William as an apprentice in his sign and ornamental painting shop in 1824. It soon became evident that young William had great potential as an artist. Henry, who was an artist in his own right and became an Associate of the National Academy of Design in 1828, apparently encouraged his brother to pursue an artistic career. It was Henry who requested that the National Academy include William's submission, *Christ Raising the Daughter of Jairus*, in its 1828 exhibition. Henry's always frail health forced him to leave his sign shop and to return to Stony Brook a few years before his death. William demonstrated his abiding affection for Henry in the sensitivity with which he executed this portrait and in the fact that he kept the palette (illustrated here) that bears Henry's name.

Portrait of Reuben Merrill 1832
Oil on canvas
54.4 × 43.3 (21½ × 17⅛)
Inscription: (on reverse, printed in small
 letters at top) *Portrait of Rueben/
 English Farm Hand/At/The Seabury's,
 Stony Brook, N.Y.* (on reverse) *Painted
 by Wm. S. Mount Sept. 25, 1832*
Museums Collection

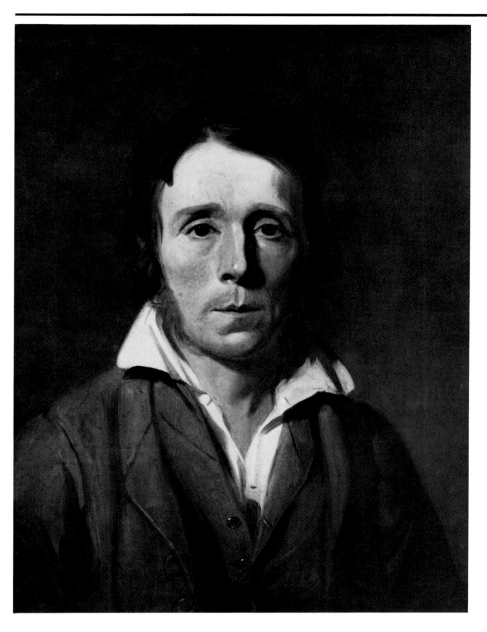

The 1832 *Portrait of Reuben Merrill* is one of Mount's finest portraits. No known documentation suggests that it was commissioned. It may be one of the portraits to which Mount referred in an 1832 entry in his "Catalogue of portraits and pictures . . .": "About this time I painted two or three portraits for practice, one sitting for each."[1]

Although both his century and ours usually identify William Sidney Mount as a genre painter, paintings such as this one demonstrate his skill as a portraitist. A nineteenth century critic recognized Mount's talent in portraiture and noted that, in comparison to his scenes of everyday life, his portraits "indicate always the same power and the same sentiment of expression, and . . . not enough attention was bestowed on them."[2] Mount's talent is especially worthy of note in this considered work, in which he portrays the subject and his mood in a quiet, informal and unassuming manner quite unlike that in which he portrayed his brother Henry.

Very little is actually known about Reuben Merrill. He was an Englishman who is believed to have worked either as a gardener or as a field hand for Mount's sister Ruth and her husband Charles Saltonstall Seabury and for their neighbors, the Williamsons. The clothes Merrill wears in the portrait are simple, and their earth tones suggest, perhaps, both Merrill's and Mount's affinity for the colors of the earth. (Mount often used the same colors in his landscapes.) Merrill's sympathetic eyes and pensive expression suggest that he was an earnest man whom Mount knew as well as he knew the fields of Stony Brook.

1 Mount, "Catalogue of portraits and pictures . . .," 7.
2 Lacombe, 1, col. 6.

46

Portrait of Mrs. Timothy Starr 1833
Oil on canvas
76.1 × 64.0 (30 × 25)
Inscription: (on reverse) *Wm. S.
 Mount/1833*
Gift of Mr. and Mrs. Hallock W. Beals,
 1947

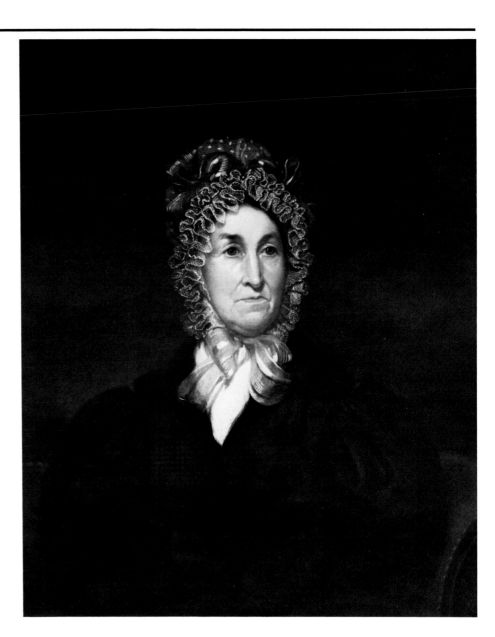

William Sidney Mount painted this portrait of Mrs. Timothy Starr in 1833. Portraits were highly prized in the first half of the nineteenth century, both as visual records of family members and as symbols of social status. As the nation industrialized and the volume of trade increased, a middle class began to grow and to prosper. This newly-affluent group often commissioned portraits, and its patronage made portrait painting a lucrative profession. William Sidney Mount reflected on the attraction of portraiture in a letter to his brother Shepard dated May 12, 1838: "I am sometimes tempted to resume portraiture. It [s?]ings 'its temptations of pleasing society, prompt pay[men]t, and ready-made looks which cost im[ita?]tion nothing.' "[1]

Mount painted portraits throughout his career. In 1858 he wrote, "All good portrait painters are Gentlemen, and cheerful in their manners—their vocation makes them so—."[2] However, the artist's later comments indicated that he had greater patience with male than with female subjects. In a diary entry dated January 18, 1860, Mount remarked that:

> When Ladies desires to be painted handsome & the color & drawing of their faces improved—and a flatering likeness obtained the artist should receive from their fair hands, 25 to 50 dollars extra—[3]

In the same entry he added, "It often happens, to paint one Lady portrait is equal to painting two Gentleman."[4]

Mount made no specific mention of this portrait of Mrs. Timothy Starr in his "Catalogue of portraits and pictures. . .". Mrs. Starr was seventy-five when she sat for this portrait. Her stern expression provides the painting's focus, but her sheer, ruffled bonnet draws attention to her delicately modeled facial features. The background light in this work, slightly less dramatic than that in Mount's 1832 portrait of his brother Henry, still suggests that early nineteenth century American artists adapted Romantic conventions in their efforts to satisfy their clients' demands for fashionable portraits.

1 William Sidney Mount, Letter to Shepard Alonzo Mount, 12 May 1838, ms, Louise Ockers Collection, published in Alfred Frankenstein, *William Sidney Mount* (New York: Harry N. Abrams, Inc., 1975), 101–02.
2 Mount, Diary/Journal 1848–1857, 146.
3 William Sidney Mount, Diary/Journal 1857–1868, 18 Jan. 1860, n. pag., ms, The Museums at Stony Brook.
4 Mount, Diary/Journal 1857–1868, 18 Jan. 1860, n. pag.

Portrait of Jedediah Williamson
c. 1837
Oil on panel
41.3 × 34.3 (16¼ × 13½)
Inscription: (bottom center) *Wm. S. Mount*
Bequest of Ward Melville, 1977

Drawing of Jedediah Williamson
c. 1837
Pencil on paper
14.7 × 20.0 (5¹³/₁₆ × 7⅞)
Inscription: (bottom center) *Wm. S. Mount*
Bequest of Ward Melville, 1977

Mount's 1837 portrait of Jedediah Williamson is a sensitive depiction of a ten-year-old boy. It differs from the artist's portraits already described in that it is what Mount called a painting "after death."[1] During the nineteenth century, it was not uncommon for patrons to commission portraits of deceased family members in an attempt to memorialize them. The practice of painting portraits after death often provided a source of steady income for struggling American artists.

Throughout Mount's career bereaved patrons summoned him to paint portraits of their deceased relatives. In his journal entries Mount repeatedly remarked on his aversion to this type of portraiture. On December 26, 1857, the artist wrote a letter to Nathaniel Smith, a patron who had commissioned portraits of his deceased son and daughter, in which he discussed portraits after death. Mount's letter reveals a technique he employed in painting portraits after death that he thought his fellow artists did not employ:

> It is proper for me to state at this time that it is not common for artists to make sketches of persons after death, and from those sketches paint portraits. I believe I am alone in this part of the art in painting almost from memory. Painters often take likenesses after plaster casts, or from Daguerreotypes—& these charges are much more than from the life—I have found by experience that painting after death costs me double and treble the time that it does to paint the living. . . .— Portraits taken after death *double price*—even at that price, I am not paid for the anxiety of mind I have to undergo, to make my efforts satisfactory to the bereaved friends and relatives.[2]

The oil portrait of Jedediah Williamson provides a frontal view of the young boy dressed in the same garments he wears in the profile drawing of 1837 (illustrated here). Examination of this painting reveals that Mount concentrated his efforts on a careful rendering of the boy's facial features. The boy looks serenely into the unidentifia-ble distance. While he paid close attention to the boy's features, Mount painted the boy's clothing with broad brushstrokes. Mount charged the Williamson family fifteen dollars for the painting. According to William Williamson's account book they paid the artist for his work in goods and services between 1838 and 1839.[3]

The *Drawing of Jedediah Williamson* is probably not an example of the type of preliminary sketch for a portrait after death that Mount mentioned in his letter to Smith. In 1837 Mount recorded in his "Catalogue of portraits and pictures . . .," "I made a sketch of Col. Williamson's Son after he was killed by a loaded waggon passing over his body."[4] This pencil sketch depicts an alert child posed with an air of dignity that befits his formal attire. It is possible that this profile sketch was done from life. While it is also possible that this sketch pre-dates the oil portrait, it is probably not a preparatory version of it. This portrait, like the oil portrait, offers no evidence of the awful manner in which the young boy met his death.

1 William Sidney Mount, Letter to Nathaniel Smith, 26 Jan. 1857, ms, The Museums at Stony Brook.
2 Mount, Letter to Nathaniel Smith, 26 Jan. 1857. Neither portrait of Jedediah Williamson could have been done from a daguerreotype since Daguerre's process was not publicly introduced in Paris until 1839, and not demonstrated in the United States until 1839/40. Interestingly enough, the Williamson family had a daguerreotype taken of Mount's portrait of their son.
3 William S. Williamson, [Account] Book, entry no. 55, ms, The Museums at Stony Brook.
4 Mount, "Catalogue of portraits and pictures . . .," 10.

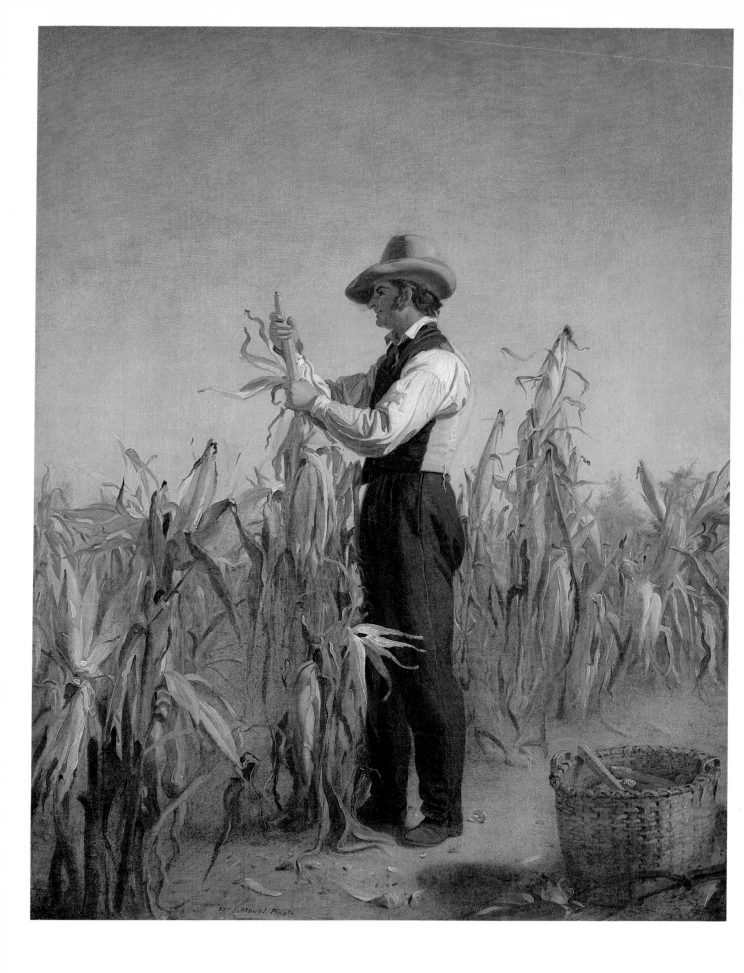

Long Island Farmer Husking Corn

1833–34
Oil on canvas
53.0 × 43.2 (21 × 17⅛)
Inscription: (lower left) *Wm. S. Mount,*
 Pixt/1834
Gift of Mr. and Mrs. Ward Melville, 1975

Long Island Farmer Husking Corn may well be the Mount painting with which most nineteenth century Americans were familiar; an engraved image of it appeared on more than twenty-five denominations of currency in at least ten states.[1] In a letter dated July 28, 1840 from Milledgeville, Georgia, Robert Nelson Mount announced to his brother: "I have in my possession the margin of a one dollar (City Council of Macon) bill, on which is engraved your picture 'The Corn Husker,' by Dawdon, Right & Heck."[2] The correct name of the engraving firm was Rawdon, Wright and Hatch. This painting garnered an additional honor for Mount; it was exhibited in the 1876 Centennial Exhibition in Philadelphia, where it must have been seen by an international as well as a national audience.

Long Island Farmer Husking Corn received attention of another sort from one of nineteenth century America's foremost humorists, Seba Smith. Ten years after Mount executed the work, Smith wrote the following commentary in the 1844 issue of the popular publication, *The Wintergreen*:

This ere picter is as much like Uncle Joshua, when he was about forty-five year old, as two peas in a pod. And well it may be, for it was drawed from real life; and there aint no more nateral picters in the world, than them that's drawed from nater.[3]

Smith's comments represent the literary trend in which writers tried to capture the unique character of the American people in dialectal forms. The humorist was probably drawn to Mount's painting because it epitomized his conception of the "Yankee farmer," a peculiarly American "character" who concealed a sharp wit beneath his rural simplicity.

William Sidney Mount made his own comments about this painting in a journal entry dated November 14, 1852: "Farmer Husking Corn—painted . . . in the open air—the Canopy of heaven for my paint room—."[4] *Long Island Farmer Husking Corn* is an early example of the artist's interest in the truthful portrayal of nature. The sense of atmosphere in the painting, the golden tonality of its corn and soil and the reflected light on its farmer's back all capture the mellow heat of a warm autumn day. An unidentified critic who saw this canvas in the National Academy's 1834 exhibition remarked:

The drapery, (the corn and the basket) in this picture is painted with a truth, and *crispness of touch*, that would do credit to a Teniers. Mr. Mount is the only artist that we know of who has taken the rustic habits of this country as subjects for the *easel*; . . . he has invested them with a charm that will prove a passport to them to the gallery of every man of taste.[5]

Mount noted in his own "Catalogue of portraits and pictures . . ." that he sold this painting to Gouverneur Kemble, Esq. for $50.00. The artist also remarked that it was "engraved for an annual."[6] The print engraved after this painting appeared in two versions (or states) and is an excellent example of the manner in which artists' works reached wide audiences in the nineteenth century.

1 John A. Muscalus, *Popularity of Wm. S. Mount's Art Work on Paper Money, 1838–1865* (Bridgeport, Pa.: Historical Paper Money Research Institute, 1965), n. pag.
2 Edward P. Buffet, Chapter XIX of "William Sidney Mount: A Biography," *Port Jefferson Times*, 1 Dec. 1923–12 Jun. 1924.
3 Cowdrey and Williams, 15.
4 Mount, Diary/Journal 1848–1857, 123.
5 "Setauket Scrapbook," 4.
6 Mount, "Catalogue of portraits and pictures . . .," 8.

Farmers Nooning 1836
Oil on canvas
51.5 × 61.5 (20¼ × 24¼)
Inscription: (lower left) *Wm. S. Mount 1836*
Gift of Mr. Frederick Sturges, Jr., 1954

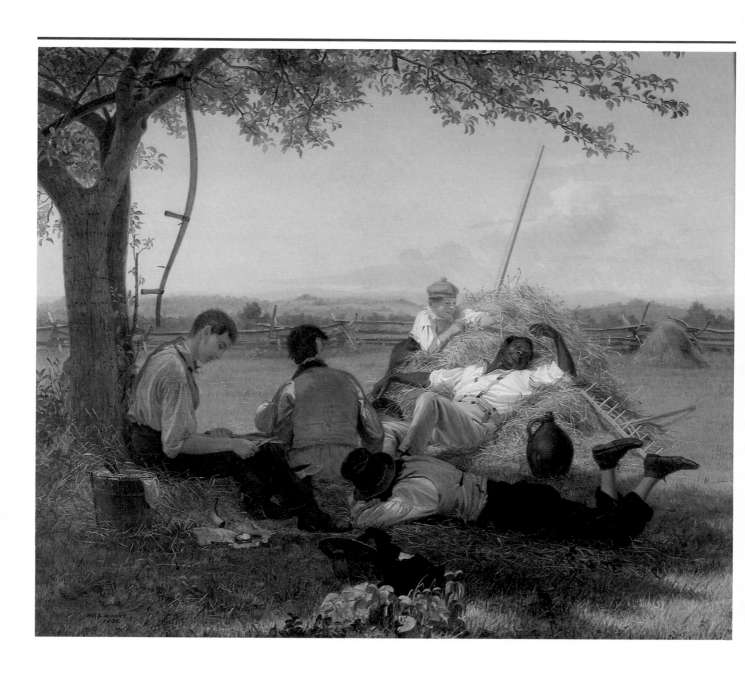

Farmers Nooning is one of William Sidney Mount's best early paintings. Mount, who refused to study in Europe, a course taken by many of his contemporaries, chose instead to train himself to focus on the subtlety and beauty of his natural surroundings. His treatment of nature and sunlight in *Farmers Nooning*, which he painted out of doors, testifies to his success.[1] Thirty years later he wrote in his "Catalogue of portraits and pictures . . . ," "When I occasionally refer back and remember the progress I made from 1827 to 1838 as one of the first that painted directly from nature (that I had ever heard of); it stimulates me to stick to nature as a short road to perfection."[2]

In preparation to paint *Farmers Nooning*, Mount made an oil sketch (illustrated back cover) whose differences from the finished work are worthy of note. Both the sketch and the painting contain five figures. In the sketch, however, the artist draws the viewer's attention to the boy who industriously sharpens his scythe, while in the finished painting the artist uses the pitchfork vertically thrust into the apogee of the haystack to draw the viewer's attention to the sleeping black man. The sky is darker in the sketch than it is in the painting, in which it is the light, clear sky of a warm late summer afternoon. The finished painting attests to Mount's masterful and truthful portrayal of nature: like the sunlight whose gentle effect on the weeds (center foreground) he so carefully describes, Mount meticulously delineates each blade of grass and each piece of straw with the care of one who paints directly from nature.

Mount's devotion to his natural surroundings extended even to his use of pigments from Long Island's rocks and soil. In a letter to the famous Long Island historian, Benjamin F. Thompson, dated December 31, 1848, Mount wrote:

= As long ago as 1836 when I was painting The Farmers nooning—my late brother H.S. Mount, handed me a piece of native umber found in the banks near this place and desired me to make use of it in my picture—I did

so—and found it as he had represented, transparent, and a good dryer—I have used it more or less ever since and find it a valuable pigment. . . . In the gradations of flesh, with white it is truly delightful.[3]

Moreover Mount was reputed to have used a Long Island locale for *Farmers Nooning*. Edward Buffet, the artist's early twentieth century biographer, wrote that Mount painted this work in one of the fields on the Mount property in Stony Brook.[4]

In the nineteenth century *Farmers Nooning* won special praise for its depiction of a black man. One unidentified critic who saw it hanging in the Twelfth Annual National Academy Exhibition in 1837 wrote:

The whole piece is admirable; but the black fellow is the masterpiece in the composition;—the nettled expression of his countenance as he feels the straw—the foreshortening of his figure—the delighted appearance of the boy—all speak the fact that Mr. Mount is indeed a great painter.[5]

Another reviewer who attended the same exhibition remarked:

what can be more true, more replete with dry humour, varied expression and character, in costume, physiognomy, repose, &c. The sprawling, sleeping negro imbedded in the straw under the apple tree's shade, grinning his noonday dreams as the young urchin insinuates the straw in his ear. . . .[6]

And W. Alfred Jones, Mount's contemporary biographer, offered the artist the following advice, considered by some at the time to be highly complimentary:

one field still remains open to him which he could worthily occupy—the Southern negro, plantation life, corn shuckings, &c. He would find openhanded patrons among the cultivated and opulent planters.[7]

Modern critics have registered mixed reactions to Mount's portraits of black Americans. They have credited him for his avoidance of the stereotypical facial characteristics that were often used to make the black man a comical figure. They have criticized him, however, for his evasion of the social issue of slavery in an era replete with antislavery sentiment.

Jonathan Sturges (1802–1874) of New York City, one of the most supportive patrons of American artists of his time, owned *Farmers Nooning*. Luman Reed, Sturges' partner in the grocery business, was an even more prominent patron of American art than Sturges. Both men owned renowned art collections; Reed, who died in 1836, owned two Mount paintings, and Sturges owned three of the artist's works. In a letter dated December 14, 1837, Sturges wrote to Mount: "I was sitting opposite the 'Farmers Nooning' *last evening* and enjoyed myself so much I suddenly felt quite anxious to get a peep at some other scene in the same line. . . ."[8]

Jonathan Sturges, although he owned *Farmers Nooning*, was not the only one able to enjoy it. The work was widely distributed throughout the country in the form of engravings done by both Joseph N. Gimbrede and Alfred Jones. Gimbrede's version appeared in the July 1845 issue of *Godey's Lady's Book*, and the color version of Jones's print was published in 1843 for the members of the Apollo Association, a New York art society.

1 Mount, Diary/Journal 1848–1857, 123.
2 Mount, "Catalogue of portraits and pictures . . . ," 43–44.
3 William Sidney Mount, Letter to Benjamin F. Thompson, 31 Dec. 1848, ms, The Museums at Stony Brook.
4 Buffet, Chapter XIII, *Port Jefferson Times*.
5 "Setauket Scrapbook," 9.
6 "Setauket Scrapbook," 11.
7 W. Alfred Jones, "A Sketch of the Life and Character of William S. Mount," *American Whig Review*, 14 (Aug. 1851), 124.
8 Jonathan Sturges, Letter to William Sidney Mount, 14 Dec. 1837, ms, The New-York Historical Society, New York, New York. Printed courtesy of The New-York Historical Society.

54

The Sportsman's Last Visit 1835
Oil on canvas
54.0 × 43.8 (21½ × 17½)
Inscription: (lower right) *Wm. S. Mount /*
 1835
Gift of Mr. and Mrs. Ward Melville, 1958

In *The Sportsman's Last Visit* Mount offers the viewer a sample of his humor: his title cleverly explains the incident that his scene describes. Both the artist's depiction of an event in an everyday setting and his use of a compressed space defined by the placement of figures and objects prompted critics to compare this work to that of seventeenth century Dutch and Flemish genre painters, the so-called Little Masters. There is no evidence to suggest that Mount actually saw any of these artists' original works. Popular nineteenth century prints after the genre paintings of Sir David Wilkie reflected that artist's indebtedness to seventeenth century Dutch painters and may well have served as sources of inspiration for Mount.[1]

Contemporary critics saw this painting in the National Academy's 1835 exhibition and praised it. One unidentified critic announced that Mount:

is a Wilkie, junior. The only one in this country. At Mount's age, Wilkie had not a third of his genius. Look at the uneasy, jealous, troubled face of the sportsman—the timid bashfulness of the lady—the perserverance of the lover in black: the whole a picture.[2]

In 1851 Mount's contemporary biographer, W. Alfred Jones, wrote that "Some of his cabinet pieces with a variety of figures deserve to be ranked in the same category with the admirable pictures of the Dutch and Flemish schools."[3]

The Sportsman's Last Visit reveals nineteenth century Americans' growing awareness that there was a broadening difference in manners between urban and rural dwellers. As the nation's larger cities became centers of increasing wealth and industry, city dwellers began to adopt an air of cultural superiority over their rural neighbors. Many of New York's leading merchants, of whom Luman Reed was a good example, had been raised in the country and felt a nostalgic attachment to it. In this painting, Mount astutely contrasts the genteel elegance of the city gentleman to the clumsy awkwardness of the intruding rural suitor who is forced to abandom his claim to the lady. The following excerpt from an 1851 issue of the short-lived New York periodical, *The Literary World*, reveals the patronizingly urban attitude that greeted Mount's rural models:

They seem to form a little world by themselves, and as far as we can guess by the look of things, they marry and give in marriage after a fashion of their own, have their feasts and frolics. . . . We would advise them, however, in all friendliness, to be a little more careful of their deportment when painter Mount is about—with that eye of his![4]

In an 1852 entry in his journal, Mount noted that he painted his canvas at General Satterlee's house in Setauket "by the aid of two south windows (.in winter). and separated by a curtain to divide the two lights."[5] The artist also recorded in an 1835 entry in his "Catalogue of portraits and pictures . . ." that he sold this painting to George P. Morris, editor of the *Home Journal*, for the sum of $100.00.[6]

1 Hoover, 7–11.
2 "Setauket Scrapbook," 4.
3 W. Alfred Jones, 126.
4 "Long Island Mount," *The Literary World*, 9 Mar. 1850, 227, col. 2.
5 Mount, Diary/Journal 1848–1857, 122.
6 Mount, "Catalogue of portraits and pictures . . .," 9.

Catching Rabbits 1839
Oil on panel
46.3 × 44.3 (18¼ × 21⅜)
Inscription: (on rabbit trap, lower right)
 Wm. S. Mount 1839 (also on reverse)
Gift of Mr. and Mrs. Ward Melville, 1958
Photo by George Roos

William Sidney Mount outlined a method he used for painting indoors when he described painting *The Sportsman's Last Visit* (1835, The Museums at Stony Brook, illustrated p. 54) in General Satterlee's house in Setauket. One of his diary entries, dated November 14, 1852, indicates that Mount employed the same method in painting *Catching Rabbits* indoors in 1839: "by the aid of two south windows (.in winter). and separated by a curtain to divide the two lights."[1] *The Sportsman's Last Visit* is an interior scene painted indoors; *Catching Rabbits*, on the other hand, is an outdoor scene which winter weather forced the artist to execute indoors. Scholars have wondered why Mount did not paint more snow scenes—only three are recorded—when such scenes were extremely popular with American artists and collectors alike.[2] Mount may have hesitated to paint such scenes because he was not able to paint them directly from nature, a practice he adopted in 1833.

Critics of Mount's time seem to have disagreed on the degree of the artist's success in painting this winter scene.

Boys trapping. (W.S.Mount.) Although the subject is not very attractive, Mr. Mount has succeeded in producing a very interesting picture—as, in fact, he generally does, even with the most common every-day scenes, by reason of the truth and beauty of the execution. We like the idea of the dry, crisp leaves and twigs, which threaten to fall with the first rush of wind. The attitude of the boy, and his grin of satisfaction, are capital.[3]

—Boys Trapping.—*Mount.*—Not one of Mount's best, by any means. There is too much of the sign painter style; the tints on the snow are not natural, neither are the trees in good keeping. The boys' clothes are intended in the drawing to represent old, ragged, and tattered habiliments; but by the style of painting they resemble the best broadcloth, newly made up from the tailor's shop. The picture will not enhance Mount's reputation.[4]

Boys Trapping.—There is character and body in every part of this Long Island scene—in the snow—in the footprints—in the foliage—in the experienced precision and care with which the elder of the boys re-sets his "figure four" and in the satisfied good humor of the other who is *hefting* the solid evidence of their success. As a whole it is the best of his works. There is no accident or forced drawing about it. He has evidently gone to his easel to paint what he thought, not to think what to paint. We heard it remarked the other day, that he ought to have scattered some of his snow upon the trees, but in our judgment the character of the footprints shows it to be "*an old snow.*"—[5]

Mount painted *Catching Rabbits* for Charles A. Davis of New York City in 1839. Stony Brook tradition identifies the two boys in *Catching Rabbits* as Henry Luke Rowland (holding the rabbit) and Lewis Davis.[6] The painting was exhibited at the National Academy of Design in 1839, and again in the Exhibition of All Nations at the New York Crystal Palace in 1853. Also included in that "world's fair" exhibition were Mount's paintings *The Power of Music* (1847, The Century Association, New York), *Raffling for the Goose* (1837, The Metropolitan Museum of Art, New York) and a version of his hollow-backed violin, the "Cradle of Harmony."

Mount's friend William Schaus arranged for *Catching Rabbits* to be reproduced as a lithograph in 1850. On January 7 of that year Mount wrote to Charles Lanman:

As you request, I will mention with pleasure, two or three of my last pieces—"Turning the Leaf," "Farmer whetting his scythe," "The Well by the wayside," and "Just in Tune." The last represents a *character tuning his violin.* The size of life, on Canvass 25 × 30. . . . It is to be published by Goupil Vibert & Co and has gone to Paris to be engraved the size of the original by the celebrated *Emile Laselle.*

Boys Trapping—painted for Chas. A. Davis of N.Y. in 1839—it is now in Paris under the magic hand of Leon Noel, and then both of the above pictures, after serving the purposes of the engraver, are to be exhibited in the ensuing collection of paintings at the Tuilleries.[7]

It is not known whether *Catching Rabbits* was exhibited at the Tuilleries, but it certainly commanded a wide audience of both Europeans and Americans because of its reproduction as a lithograph.

1 Mount, Diary/Journal 1848–1857, 122.
2 Mount's three known snow scenes are: *Catching Rabbits* (1839, The Museums at Stony Brook), *The Trap Sprung* (1844, The Museums at Stony Brook) and *Snow Balling* (n.d., The Museums at Stony Brook).
3 "Setauket Scrapbook," 9.
4 "Setauket Scrapbook," 9.
5 "Setauket Scrapbook," 11.
6 These identifications are recorded in a note made by Margaret Wall, former Director of The Museums at Stony Brook.
7 William Sidney Mount, Letter to Charles Lanman, 7 Jan. 1850, ms, The New-York Historical Society, New York, New York. Printed courtesy of The New-York Historical Society.

Loss and Gain 1847
Oil on canvas
61.0 × 50.6 (24 × 20)
Inscription: (bottom center) *Wm.S.
Mount/1847*; (on reverse) *Loss and
Gain/by Wm.S.Mount/1847*
Bequest of Ward Melville, 1977

William Sidney Mount addressed an issue that concerned many nineteenth century Americans—temperance—in this painting which he cleverly titled *Loss and Gain*. The temperance movement, the crusade against "Demon Rum," gained momentum after the War of 1812 when Protestant churches gave it their support. The original purpose of the movement had been to encourage moderation in drink among the working classes, but as its members became more radical and more zealous, its purpose became the enforcement of total abstinence, a change which cost it many supporters (including many upper class advocates and many organized churches). In the 1830s and 1840s the temperance movement adopted the tactic of the testimonial—women, children and reformed drinkers recounting the evils of drink—a tactic that may have convinced converts but did not necessarily increase support.[1]

The entries in Mount's diaries and the temperance materials in his library suggest that the artist was as concerned as many of his contemporaries about the subject of temperance. Although Mount loved lively company, his fragile health and his strength of will evidently prevented him from falling prey to the evils of drink. On April 1, 1857 Mount wrote to his friend James Baxter:

> To come square to the point with you my dear friend—I must tell you that liquor drinking is a nuisance. . . . Drinking causes one to be stupid, and to lose ambition about business, and indifference about personal appearance. . . . As for myself, I have drilled my will power so, for the past year—that I can sit and look at bottles without any inclination to drink."[2]

Mount's paintings of temperance subjects are those of a man whose will appeared to be unassailable. In 1832 Mount painted *A Man in Easy Circumstances* (present location unknown), of which he remarked: "The . . . picture was painted for the temperance society. The Gentleman who engaged it, said after viewing it— 'Mount, that will never do you have represented the drunkard so happy, that it will not answer for the cause'."[3] In 1849 he painted *Loss and Gain*, in which a tired drunk reaches desperately for his overturned jug. The painting's title neatly presents its moral: the hapless man's loss of his liquor is his moral gain. Elements of the painting's composition—the man's gaze, his reaching arm and the tree's root—direct the viewer's attention to the liquor leaking out of the jug. The old man's disheveled appearance—his fallen hat, his open shirt and his torn pants—suggests that he may have lost his jug a little too late.

Mount commented that he painted the landscape in this work partly from nature, but that he painted the figure in his studio. Mount applies his paint thinly to describe the various textures of the landscape in this work. Here his fine sense of natural detail recalls that sensitivity evident in his earlier works painted from nature, *Farmers Nooning* and *Long Island Farmer Husking Corn*.

When *Loss and Gain* was included in the National Academy of Design's 1848 exhibition, it was well received. One critic remarked, "The ludicrous distress of the old rum-sucker is quite laughable. . . . The artist loses nothing of his early fame by this production."[4] Another reviewer related an anecdote that Mount himself had told. As a boy, the artist:

> saw a similar scene, and while the liquor, in its struggle to escape from the bottle, produced a jerking sound resembling the word 'good, good, good,' the poor toper exclaimed . . . 'well, I know you are good, but I can't reach you!'[5]

Loss and Gain may have encouraged temperance advocates in the support of their cause, but it inspired Mount to a different sort of action. Mount sold the painting to Robert Fraser, who must have made its subsequent sale to the American Art-Union (an organization dedicated to the dissemination of American art to a wide audience) possible. The Art-Union sold prints to subscribers, mounted exhibitions and held an annual lottery whose prize was an original painting. Mount was disgusted when he learned the fate of his painting and wrote to George Pope Morris, the editor of the *Home Journal*:

> The one now in the Art-Union— 'Loss & Gain'—was not obtained from me. I sold it to Robert F. Fraser Esqr. The Art-Union does not give orders this year, but intend to buy pictures at low *prices* to grind the *Artist* down.[6]

An unidentified critic reported at the time that *Loss and Gain* was to be reproduced as a print in a series that included Francis W. Edmonds' *Facing the Enemy* (1845, private collection), another work that illustrated the evils of drink.[7] *Facing the Enemy* was engraved by T. Doney (an engraver working in New York between 1845 and 1852) and distributed by John Ridner (who intended to market it to temperance advocates).[8] No available evidence documents the similar reproduction of *Loss and Gain*.

1 Leonard L. Richards, *The Advent of American Democracy, 1815–1848*, The Scott Foresman American History Series, Ed. Carl N. Degler (Oakland, N.J.: Scott, Foresman and Company, 1977), 111–14.
2 William Sidney Mount, Letter to James Baxter, Apr. 1857, ms, The Museums at Stony Brook.
3 Mount, autobiographical notes, Jan. 1854, 5.
4 "Setauket Scrapbook," 19.
5 "Setauket Scrapbook," 24.
6 William Sidney Mount, Letter to George Pope Morris, 3 Dec. 1848, in Alfred Frankenstein, *William Sidney Mount*, 234. Frankenstein lists this letter as being at The Museums at Stony Brook, but there is no record of The Museums ever having owned it.
7 "Setauket Scrapbook," 24.
8 Maybelle Mann, *Francis William Edmonds*, Exh. Cat. (Washington, D.C.: International Exhibitions Foundation, 1975–1976), 24.

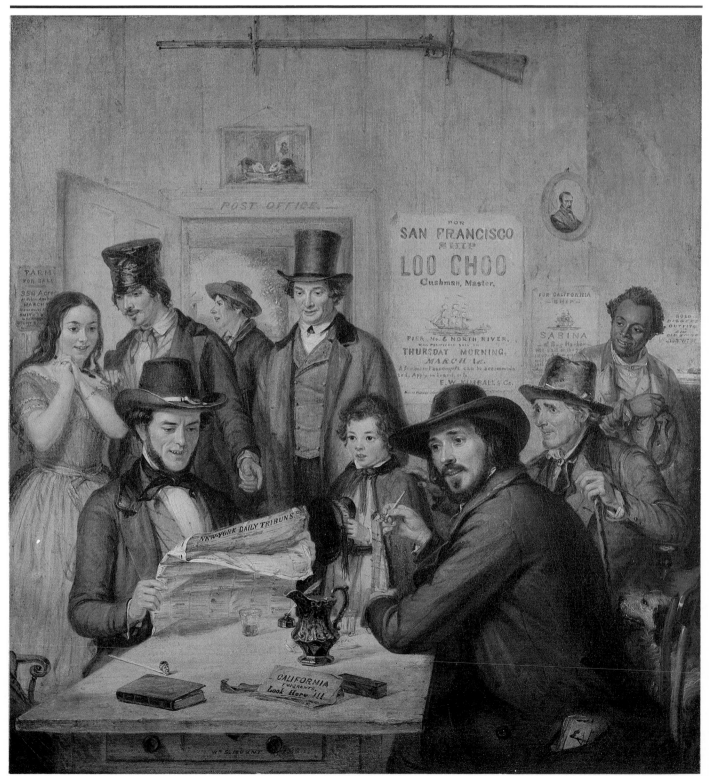

California News 1850
Oil on canvas
54.5 × 51.4 (21½ × 20¼)
Inscription: (bottom left) *Wm. S. Mount*;
 (bottom center) *1850*
Gift of Mr. and Mrs. Ward Melville, 1955

California News is William Sidney Mount's account of the Gold Rush. The promise of West Coast riches weighed heavily on the minds of many nineteenth century Long Islanders. When the news of James Marshall's 1848 discovery of gold at Sutter's Mill reached the East Coast many men forsook their communities, their farms, and even their families for passage to San Francisco. Along with the news came rumors, stories and songs. *The Long Islander* newspaper printed a song (to be sung to the tune of "Oh Susannah") in one of its 1849 issues that included the following verse:

I soon shall be in Francisco
And then I'll look around,
And when I see the gold lumps there,
I'll pick them off the ground.[1]

Mount, who was apparently unaffected by the gold fever, wrote this entry in his journal on December 22, 1848:

= For about two months past there has been great excitement about the *Gold Placer's*, in *north California*. Thousands are rushing there to have a hand in sifting, & picking—I hope It may turn out a blessing to the country— than a curse =[2]

Because it depicts a contemporary event, *California News*, also called *News from the Gold Diggings*, represents Mount's departure from his own artistic convention. He painted it for Thomas McElrath, co-publisher (with Horace Greeley) of the New York *Daily Tribune*. It is hardly surprising that Mount gives the *Daily Tribune* such a prominent place in this composition. An unidentified critic reported that this canvas "was painted for Mr. McElrath of the Trib-une, and represents a party reading that clever and deserving paper containing the news from California, when the yellow fever [gold fever] was first breaking out."[3]

Edward Buffet described the room in which *California News* is set as a tavern room that adjoined the Stony Brook Post Office. Buffet also suggested that Mount used the Hawkins-Mount House as his model for the tavern room.[4] Prior to the 1817 death of Jonas Hawkins (Mount's grandfather), the Hawkins-Mount House is supposed to have been a tavern and a store, as well as a home.[5] Although Mount is supposed to have used his friends and relatives as models for this composition, he identified none of them. George J. Price, Jr., one of the painting's former owners, tentatively identified three of its figures: the gentleman reading the paper is George J. Price, Sr. (the owner of Mount's *Just in Tune*), who purchased *California News* from McElrath; the man seated at the table to the right is the artist's brother, Shepard Alonzo Mount; and the young woman on the left is the artist's niece, Maria Seabury.[6]

Mount fills *California News* with the excitement of the Gold Rush. The young woman appears to be enthralled by the news of the discovery and the man in the doorway calls others to hear the report. The broadsides posted to the right of the doorway announce ships bound for the California coast, while the broadside posted to the left of the doorway announces the sale of a farm, a very real consequence of departure for the gold fields. It has been suggested that Mount includes his brother Henry's painting, *Girl with Pigs* (c. 1831, The Museums at Stony Brook), in this composition (over the doorway) as a silent but mocking remark on the greed of those who hunger for gold.[7] Mount's compact arrangement of the composition's nine figures en-hances the restless excitement that it generates. He reinforces the newspaper's prominence in the composition by including diagonal lines (the tall man's pointing left arm and the broadside lying on the table) that point to it. Finally Mount paints the entire composition with warm earth colors, which he accents with red, the color of excitement.

The painting was well received in its day. W. Alfred Jones, the artist's contemporary biographer, wrote:

California News is a hit at the times. A group of listeners around the reader of the 'extra,' containing the miraculous developments of gold discovery at the El Dorado. . . . This is, altogether, a capital thing, full of telling effects: an historical painting, though of an humble order, in the genuine sense.[8]

1 Harriet J. Valentine, *The Window to the Street: A Mid-Century View of Cold Spring Harbor, New York. Based on the Diary of Helen Rogers* (Smithtown, N.Y.: Exposition Press, 1981), 103.
2 Mount, Diary/Journal 1848–1857, 34.
3 "Setauket Scrapbook," 21.
4 Buffet, Chapter XXV, *Port Jefferson Times*.
5 Zachary N. Studenroth, "The Hawkins-Mount Homestead: An Historic Structure Report," TS, The Museums at Stony Brook, 1979, 13.
6 Anne D. Price, Letter to Margaret Wall, [1936], ms, The Museums at Stony Brook. George J. Price, [Jr.], the son of George Price who purchased *California News* from McElrath made these identifications in 1936. In 1942 his niece, Anne D. Price, sent a copy to Margaret Wall, Director of the Suffolk Museum. Miss Price noted that Richard Gipson, Ward Melville's agent for purchasing Mount paintings, questioned Price's identifications. A portrait recently donated to The Museums collection confirms the identification of George Price, Sr., as the gentleman reading the newspaper in *California News*.
7 David Carew Huntington, *Art and the Excited Spirit: America in the Romantic Period*, Exh. Cat. (Ann Arbor, Mich.: The University of Michigan Museum of Art, 1972), 9.
8 W. Alfred Jones, 125.

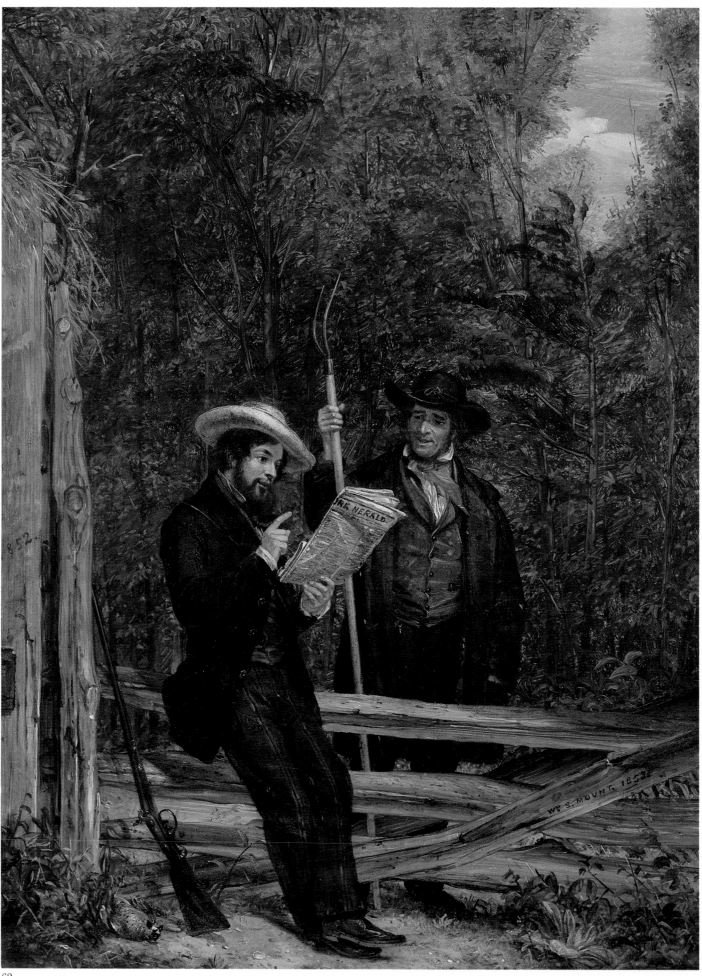

The *Herald* in the Country 1853
Oil on panel
43.4 × 32.2 (17¼ × 12¾)
Inscription: (lower right) *Wm. S. Mount/1853*
Gift of Mr. and Mrs. Ward Melville, 1955

William Sidney Mount offers a humorous glimpse of American politics in *The Herald in the Country* (1853), also known as *Politics of 1852* and *Who Let Down the Bars*. The alternate titles allude to the 1852 presidential election in the same way the title of the artist's *Cider Making* (1841, The Metropolitan Museum of Art, illustrated p. 9), alludes to William Henry Harrison's "Log Cabin and Hard Cider" presidential campaign of 1840.[1] Mount actively supported the conservative faction of the New York State Democratic party. Between 1831 and 1854 this political faction strongly opposed the Jacksonian "fiscal radicalism" that outlived the president who initiated it. Although art historians have suggested that Mount's works reflect the virtues of Jacksonian democracy, the artist's political affiliations suggest that his allegiance lay elsewhere. The apparent contradiction between Mount's artistic and political commitments is similar to that manifested in the career of his artistic contemporary, George Caleb Bingham.[2]

The Compromise of 1850 was a major issue in the election of 1852. Its component measures—the admission of California as a free state, the organization of New Mexico and Utah as territories whose residents would be free to decide the status of slavery within their borders, the settlement of Texas boundary claims, the prohibition of the slave trade in the District of Columbia and a more stringent fugitive slave law—were passed in 1850 in an attempt to address the issue of the extension of slavery into the territory recently gained by the United States. The 1852 election of Franklin Pierce, one of its supporters, demonstrated the nation's confidence in the Compromise. That election's Democratic landslide was partly the result of a sectional split that demolished the Whig party. A modern writer has suggested that this painting's alternate title, *Who Let Down the Bars*, is Mount's disgusted comment on the southern Whigs' wholesale abandonment of their party.[3]

In *The* Herald *in the Country* Mount makes no overt reference to the turbulent politics of 1852. He sold the painting to Goupil and Company, who published a print after it in 1854. According to a press release (c. 1855) written by William Schaus, "In 1853 Mr. Goupil Jr. purchased . . . 'Letting down the bars,' a political allusion to the late presidential election."[4] According to Mount's recent biographer, Alfred Frankenstein, Goupil and Company changed the title of the print version to *THE "HERALD" IN THE COUNTRY* to market it to an international audience for whom references to American politics would have had little meaning.[5]

A newspaper occupies a prominent position in *The* Herald *in the Country* as it does in *California News*. However, the *Herald* was a politically independent newspaper, unlike the Whig-oriented New York *Daily Tribune*.[6] Edward Buffet contended: "It is not unlikely that Mount's advertisement of the 'N.Y. Tribune' by his picture of News from California had created a desire on the part of the owners of the 'Herald' to get even and that they had inspired the choice of a subject."[7] Although Buffet's theory remains unsubstantiated, it is true that Mount formulated the idea of using the *Herald* in a composition as early as 1850, the same year he painted *California News*.[8]

The Herald *in the Country* is also said to have been inspired by an incident that involved Mount and his neighbor, Col. Nathaniel Hawkins. According to Hawkins' granddaughter, when Hawkins caught the artist (allegedly the figure on the left) on his property, the ever-resourceful Mount pulled a copy of the newspaper out of his pocket and began to discuss politics. Hawkins reportedly became so engrossed in the conversation that he forgot to reprimand his neighbor for poaching.[9]

In this canvas Mount uses the warm rich colors of autumn in the country. He masterfully renders the farmer's perplexed expression and the sportsman's mockingly serious expression. Mount describes the newspaper

with the meticulously precise brushstrokes that he uses for much of the foreground, while he describes the trees in the background with freer, more suggestive brushwork.

Mount exhibited *The* Herald *in the Country* at the National Academy of Design in 1853. It was well received by the critics, who praised its political relevance as well as its portrayal of the wily sportsman and the less wily farmer. Critics offered various interpretations of the painting's cryptic title. One suggested that the title derived from the dismantled fence: "The bar of the fence has been displaced, and the farmer, suddenly emerging from a pine thicket . . . accosts the New Yorker with 'Who let down the bars.'"[10] Another offered the following narrative account of the painting:

> The scene is laid just prior to the Presidential election, and the farmer, in his anxiety to learn the current intelligence . . . forgets the cause of his anger, and seems to regard the trespasser in much the same light as people generally look upon the postman. . . . It is evident the HERALD, like music, hath 'soothed the savage heart,' for not a trace of anger is visible on the face of the agriculturist, while the sportsman can ill conceal his joy at his fortunate escape.[11]

1 Joseph B. Hudson, Jr., "Banks, Politics, Hard Cider, and Paint: The Political Origins of William Sidney Mount's 'Cider Making'," *The Metropolitan Museum Journal*, 10 (1975), 114–117.
2 Hudson, 108.
3 Barbara Groseclose, "Politics and American Genre Painting of the Nineteenth Century," *Antiques*, 120 (1981), 1214.
4 William Schaus, Press Release, c. 1855, as quoted in Alfred Frankenstein, *William Sidney Mount*, 153.
5 Alfred Frankenstein, *Painter of Rural America: William Sidney Mount, 1807–1868*, Exh. Cat. (Stony Brook, N.Y.: The Suffolk Museum, 1968), 51.
6 Groseclose, 1214.
7 Buffet, Chapter XXXVII, *Port Jefferson Times*.
8 Mount, Diary/Journal 1848–1857, 90.
9 "THE 'HERALD' IN THE COUNTRY/1853/William S. Mount," 1956, TS, The Museums at Stony Brook.
10 "Setauket Scrapbook," 25.
11 "Setauket Scrapbook," 31.

Dance of the Haymakers 1845
Oil on canvas
62.4 × 76.0 (24½ × 29⅞)
Inscription: (bottom left) *Wm. S.
 Mount/1845*
Gift of Mr. and Mrs. Ward Melville, 1950

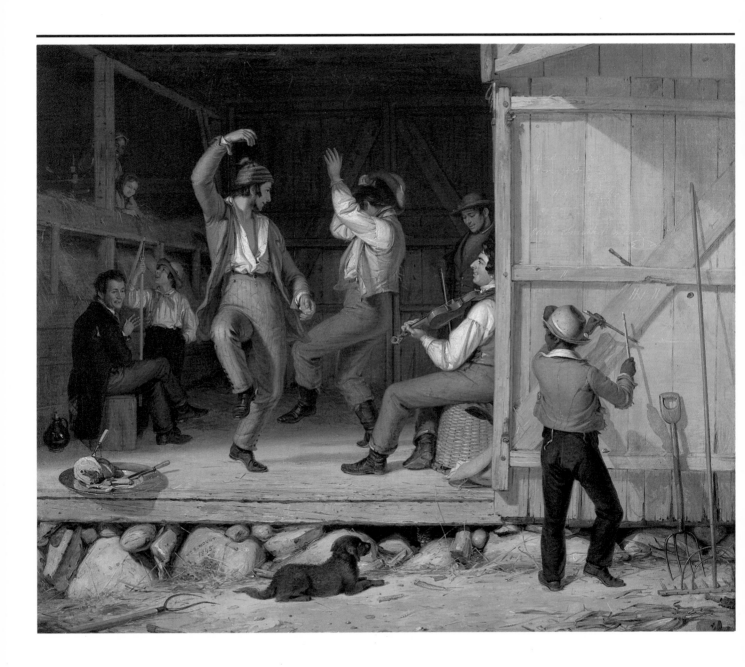

Study for Dance of the Haymakers and
The Power of Music c. 1845
Pencil on paper
22.9 × 14.0 (9 × 5½)
Bequest of Ward Melville, 1977

The masterful composition and the high-spirited action of *Dance of the Haymakers* mark William Sidney Mount's mature artistic style. This painting was commissioned by one of the nineteenth century's major New York patrons of American art, Charles Mortimer Leupp (1807–1859). Leupp was an unusually enthusiastic patron who befriended many artists and who, like Jonathan Sturges and Luman Reed, was a member of the association of New York writers, patrons and artists known as The Sketch Club. Mount recorded Leupp's favorable reaction to *Dance of the Haymakers* in his autobiographical notes for the year 1845: "Music is contageous. Painted for Charles M. Leupp, Esqr—he generously paid me twenty five dollars more than my charge."[1] In 1846 Mount was commissioned to paint a companion piece for Leupp's mother-in-law, Mrs. Gideon Lee. He completed that painting, entitled *The Power of Music* (illustrated p. 67), in 1847.

Mount's undated sheet of two sketches (c. 1845, illustrated here) indicates that he conceived the ideas for both *The Dance of the Haymakers* and *The Power of Music* at the same time, even though he executed the first painting in 1845, and the second in 1847. On March 11, 1845, Mount wrote to Leupp, "I am pleased to say that the order you so kindly gave me, has interested my feelings for some time."[2] The artist altered both compositions somewhat when he transferred them to canvas. In the finished painting *Dance of the Haymakers* he replaced the black man outside the barn with a small boy playing sticks, and he added several additional figures inside the barn. In the finished painting *The Power of Music* Mount made fewer changes with regard to his original sketch.

The finished version of *Dance of the Haymakers* is composed of figures whose vigorous movements and gestures unite harmoniously to focus on the activity in the barn. The artist conceived the painting in geometric terms: he balanced the horizontal barn floor and the vertical door boards with the diagonal lines in the barn's interior formed by the fiddle and the dancers' limbs. Mount skillfully creates the illusion of the barn's weathered wood, replete with knotholes and splinters. The scene almost vibrates with the rollicking energy of the dancers and the rhythm of the fiddler and

his young accompanist. A modern scholar astutely remarked: "With Yankee wit Mount makes a platter of ham spiral and pirouette and the tines of a hayfork bound in sympathy with the nearby dancer."[3]

Dance of the Haymakers is unique in that Mount himself identified its fiddler— Shepard S. Jones—a Stony Brook area musician whose talents Mount greatly admired. The Museums at Stony Brook's collection includes a copy of the print after this painting which Mount inscribed to Jones, and which he annotated on its verso with a transcription of a "Hornpipe composed by Shepard S. Jones Esqr 1849." This painting exemplifies Edward Buffet's 1923 comment that "The residents of Stony Brook and Setauket today view his [Mount's] *genre* painting as an ancestral portrait gallery."[4] Several of the figures in the painting have been tentatively identified as follows: the dancer on the right, Wesley Ruland; the dancer on the left, Tom Briggs; the black boy, Mathias, Jones's apprentice; and the man behind the fiddler, Horace Newton, a wheelwright from Stony Brook.[5] *Dance of the Haymakers* was the second in Mount's series of barn interiors featuring rural musicians. (The first was *Dancing on the Barn Floor*.) The dance performed in this painting has been identified as a jig, a dance which enables its performers to demonstrate individualized steps and gestures.[6]

Here, again, Mount includes black Americans in a scene of rural life. Mount effectively separates the black boy and the black woman from the main activity on the barn floor by placing them outside the barn and in the loft respectively. Mount's placement of these figures subtly reflects the predominantly separatist racial attitudes of nineteenth century America. The artist's placement of another figure in this painting may reflect an equally interesting but perhaps less often noted nineteenth century American attitude—the other figure in the loft is a white woman.

Dance of the Haymakers was exhibited in the National Academy's 1845 exhibition. An unidentified critic from the *Broadway Journal* saw it and remarked, "This is one of those works that produces the intense degree of pleasure we call tickling."[7] Another critic wrote, "Perfect in character. Like all of Mr. M.'s familiar scenes, the expression and details leave nothing to be wished for."[8] The painting epitomizes another contemporary critic's appraisal of Mount's depictions of nineteenth century rural Long Island pastimes:

> there is movement and life in his pictures, and especially a local sentiment pertaining to the earth, as it were, which strikes at first sight any one who has travelled through the State of New-York and studied American life.[9]

The painting attracted the attention of William Schaus, an agent for the French print publishing firm Goupil, Vibert & Co. Charles Lanman introduced Schaus to Mount in 1847. The agent's enthusiasm for Mount's work led to the eventual publication of six lithographs after the artist's paintings. *The Power of Music* was the first Mount painting after which a lithograph was made. In 1849 *Dance of the Haymakers* was printed under the title *Music is Contagious* as its companion piece.

Mount and Schaus carried on an active correspondence throughout their business association. On August 5, 1849 Mount wrote to Schaus:

> I have just returned from an excursion and am happy to find a letter from you, announcing the arrival shortly of a proof copy of 'Music is Contagious' . . . and if it is as well done as the 'force of music,' I will be satisfied. In the coloured plates, excuse me if I request that the negro is not coloured blue black . . . Figures should be colored true to the picture. . . .[10]

Alphonse-Léon Noël drew the final version of this lithograph on the stone. The print was issued in both color and black and white, and served to introduce Mount's unique talent to a broader American audience as well as to an international one.

1 Mount, autobiographical notes, Jan. 1854, 10. The title by which Mount refers to the painting is actually the one Goupil, Vibert & Co. gave to the print after the painting.
2 William Sidney Mount, Letter to Charles M. Leupp, 11 Mar. 1845, ms, The Museums at Stony Brook.
3 Huntington, 6.
4 Edward P. Buffet, "William Sidney Mount and His Environment," *The New-York Historical Society Quarterly Bulletin*, 7 (1923), 83.
5 Edward H. Davis, Letter to Amelia [Clay], 4 Jan. 1933, photocopy ms, The Museums at Stony Brook. Edward Davis and Amelia Clay were descendants of Shepard Jones.
6 Buechner, "Music and Dance in the Paintings of William Sidney Mount," 10.
7 *The Broadway Journal*, 10 May 1845, 305–06.
8 "Setauket Scrapbook," 15.
9 Lacombe, 1, col. 8.
10 William Sidney Mount, Letter to William Schaus, 5 Aug. 1849, ms, The New-York Historical Society, New York, New York. Printed courtesy of The New-York Historical Society.

The Power of Music 1847
Oil on canvas
43.2 × 53.3 (17 × 21)
The Century Association, New York

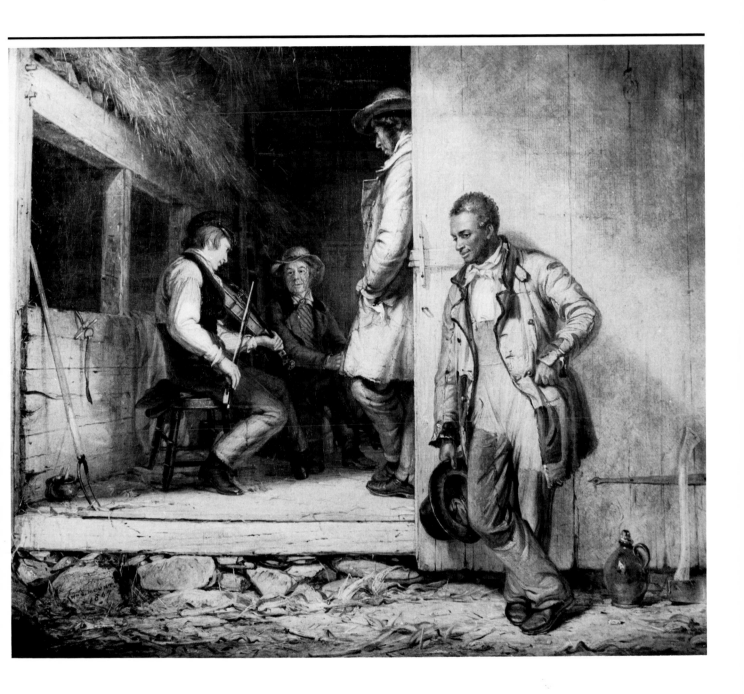

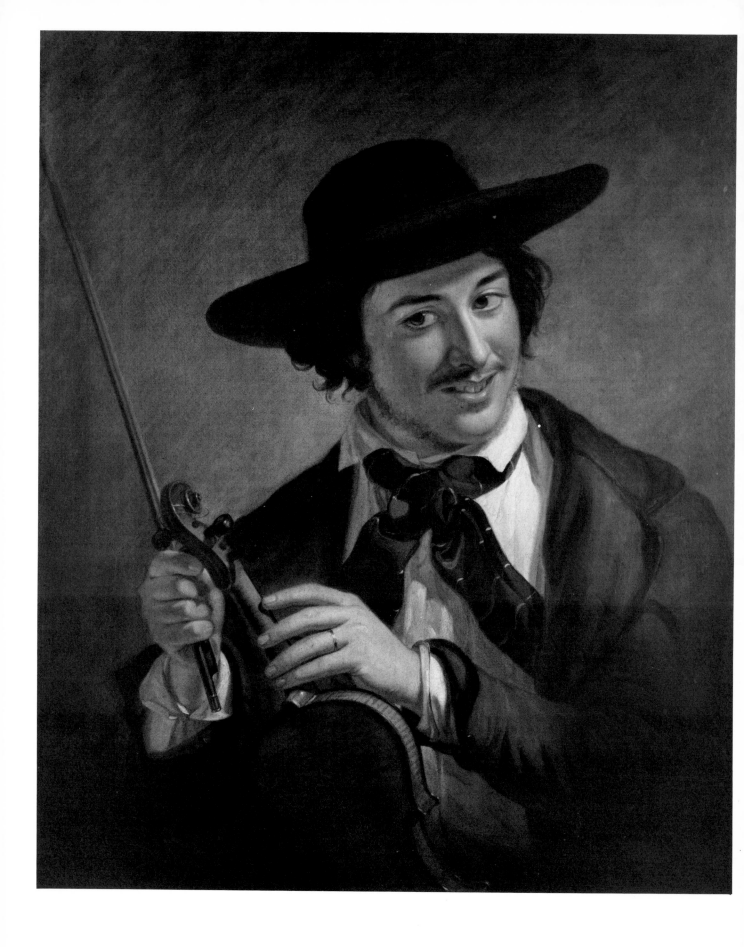

Just in Tune 1849
Oil on canvas
75.0 × 62.5 (29½ × 24⅝)
Inscription: (on violin) *W.S.M.*; (on reverse) *Just in Tune by Wm. S. Mount, 1849*
Gift of Mr. and Mrs. Ward Melville, 1955

*J*ust in Tune was the first in a series of life-size "fancy pictures" Mount painted that were reproduced as lithographs. The widely disseminated prints won the artist an international reputation. This painting is called a "fancy picture" because it depicts an imaginary character whose likeness is drawn from a real subject. Edward Buffet commented: "It is believed that while not a true likeness was painted, the man who furnished the figure for Just in Tune . . . was Robert N. Mount."[1] Mount's brother, whom he affectionately called Nelson, was a dancing instructor and a musician who often contributed fiddle tunes to his brother's music collection. Whether or not Robert sat for this painting, its subject gave William a chance to concentrate on music and art, the two pursuits he loved best.

Just in Tune depicts a young man who tips his head rakishly as he listens to the notes from his violin. Mount applies his paint thinly to the surface of this canvas. The artist convincingly suggests both the soft texture of the hair on the young man's chin and the hard surface of the violin's finely grained wood. The diagonal lines of the man's right shoulder and left arm intersect at the peg being tightened, an artistic device that cleverly reinforces the title of the work.

Oscar Bullus, one of Mount's many patrons, wrote to the artist on September 24, 1849:

I do wish you would allow the public to see your "California Boy"—that mischievous looking dog, tuning his violin preparatory to a "break down" . . . I do really think you can find a purchaser for it on your own terms—[2]

It is not known why Mount's correspondent referred to this canvas as "California Boy:" it has been suggested that Bullus may have used that phrase because it described the subject's costume, one that resembled the costume worn by prospectors in California.[3] Bullus was correct in his assumption that Mount would have little trouble finding a purchaser for this painting. He found two. William Schaus, an agent for Goupil, Vibert & Company, was well aware that the painting had been sold to George J. Price, Sr. when he wrote to Mount on November 9, 1849:

You say, that You are pleased to know that I would like Your "Just in Tune!" for the new gallery, but can I obtain it? . . . It would afford me the UTMOST pleasure to have this picture, because it is a real gem in every respect. Why! You can paint some other picture for Your friend.[4]

Although Schaus was unable to purchase the painting, he was able to convince Mount to allow his company to publish lithographed reproductions of it. On January 7, 1850, Mount proudly reported to his friend Charles Lanman that *Just in Tune* had "gone to Paris to be engraved the size of the original by the celebrated *Emile Laselle*."[5]

The lithograph after *Just in Tune* was enthusiastically received, as was the painting when it hung in the National Academy of Design's 1851 exhibition. The lithograph may have acquired the erroneous title "Just in Time" as a result of W. Alfred Jones's attribution of that title to the painting in his 1851 biography of Mount. An unidentified critic praised the lithograph:

The head represents a handsome young countryman in the act of tuning a violin . . . He is a rustic beau, apparently, somehow after the fashion of a rural Adonis, by Morland, whose powers of gallantry are as irrisistible as the exhilarating strains of his violin.[6]

This image of a "rural fiddler" was also used in an advertisement. The January 1853 edition of *The Musical Review and Chorale Advocate*, edited by C.M. Cady, contains a version of it engraved on wood by Richardson and Cox.[7]

1 Buffet, Chapter XXXV, *Port Jefferson Times*.
2 Oscar Bullus, Letter to William Sidney Mount, 24 Sep. [1849], ms, The Museums at Stony Brook. In a musical work, a "breakdown" is a musician's opportunity to demonstrate his talent in a vigorous solo performance.
3 Buechner, "Music and Dance in the Paintings of William Sidney Mount," 14.
4 William Schaus, Letter to William Sidney Mount, 9 Nov. 1849, ms, The Museums at Stony Brook.
5 William Sidney Mount, Letter to Charles Lanman, 7 Jan. 1850, ms, The New-York Historical Society, New York, New York. Printed courtesy of The New-York Historical Society.
6 "Setauket Scrapbook," 33.
7 According to William Young's *A Dictionary of American Artists, Sculptors and Engravers* (Cambridge, Mass.: William Young and Co., 1968), the engravers may have been James H. Richardson (working in New York City 1848–1850) and Thomas Cox, Jr. (working in New York City 1850–1860).

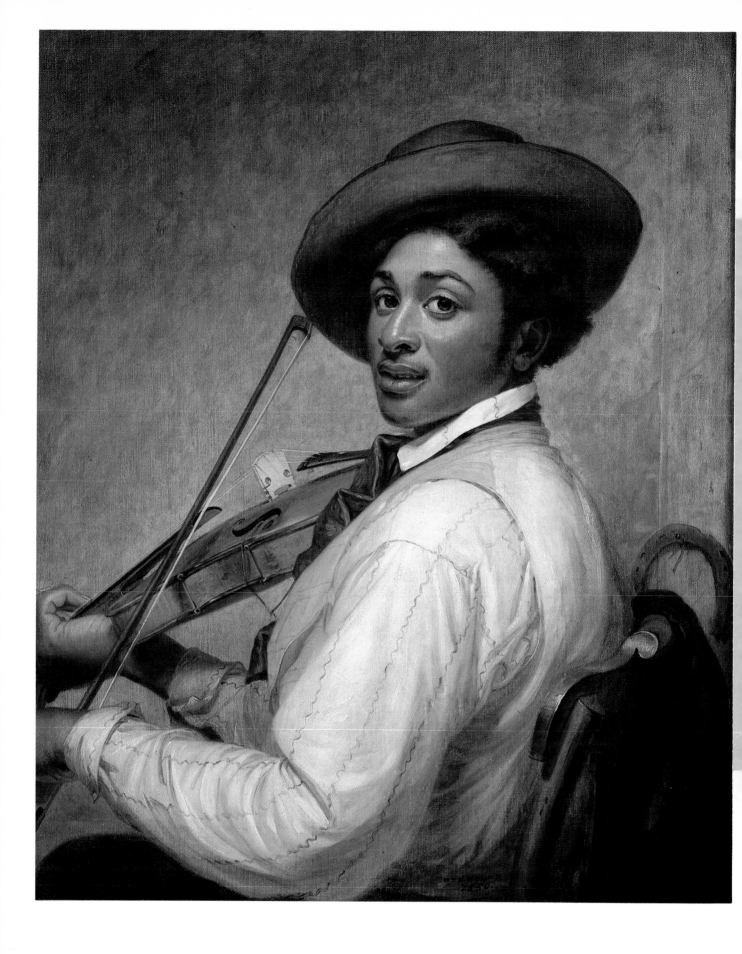

Right and Left 1850
Oil on canvas
76.5 × 64.0 (30⅛ × 25¼)
Inscription: (bottom right) *Wm. S. Mount/
 1850*; (on reverse) *Right and Left*
Museums Collection

Right and Left 1852
Jean-Baptiste Adolphe Lafosse (after
 William Sidney Mount)
Lithograph on paper, with painted frame
88.9 × 61.0 (35 × 24)
Inscription: (bottom, left to right) *Lafosse/
 Painted by Wm. S. Mount / Right and
 Left*
Museums Collection

In 1850 William Sidney Mount painted *Right and Left* as a companion piece to *Just in Tune*, which he had painted the year before. William Schaus, an agent for Goupil and Co., expressly commissioned *Right and Left* early in 1850 with the intention of transforming it into a lithograph. Mount's correspondence with Schaus shows that the agent was responsible for the selection of a black man as the model for the fiddler. On March 3, 1850, Mount wrote to Schaus: "Do you wish a negro man, or a white man as a companion to the picture 'Just in Tune'? Will the same size canvass answer?"[1] On March 7, 1850, Schaus replied:

> I think a Negro would be a good companion to "Just in tune" the size I think is good also. You have probably already an Idea what You intend make the Companion & I hope You will finish it soon.[2]

Mount finished the painting the same year, and sold it to Schaus for $150.00.[3]

The choice of a black model for this composition is quite significant. The black man (and woman) appealed to the nineteenth century European taste for "exotic" types, and proved to be an excellent subject for Mount's entrepreneurial venture.[4] *Right and Left*, like *Just in Tune*, is a "fancy picture." The character in *Right and Left* may be imaginary, but his face and his instrument are real. The violin was an instrument often associated with nineteenth century minstrel shows. A black fiddler would have been a figure as readily identified by Americans as by Europeans who knew of those distinctly American musical productions. Although Mount has been credited with avoiding caricature in his images of black Americans, one modern author has noted that Mount:

> was a man of his time. . . . He recognized the Negro as an American type, an integral part of the rustic life he idealized, yet he never painted blacks in their own social life, outside of the white context.[5]

The lithograph of *Right and Left* illustrated here is a unique example of an unnumbered edition printed by Goupil and Co. in 1852. The painting depicts a left-handed fiddle player (rather than the usual

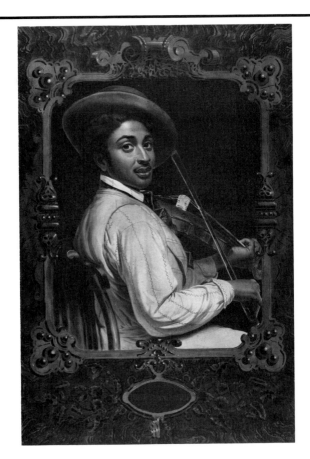

right-handed fiddler), a twist that is noted in its clever title, *Right and Left*. In the course of the lithographic process, the image was reversed, obliterating the humor Mount had intended his title to convey. The print by Jean-Baptiste Adolphe Lafosse (1810–1879) lacks the vibrant colors and the lively spirit of the original painting, although these qualities may only seem to be lost because of the print's aged and faded condition. An unidentified artist (possibly Mount himself) gave this particular print an elaborate though false "carved" frame. The watercolor and gouache frame appears to have been based on a stencil pattern, but it makes the print appear to be a treasured heirloom, not the relatively inexpensive popular print that it is.

The painting from which this print was made was sold to David A. Wood for $55.00 in 1857. In 1860 Wood allowed the painting to be exhibited at the National Academy of Design. The painting, however, had met with great critical acclaim as early as 1850:

This latest fruit of the genius of the artist, of whom the country is so justly proud, we confidently predict must make a hit. It is conceived with great spirit and truth of nature. . . . He [the fiddler] is indeed a *chef d'ouvre* of Ethiopian portraiture, and holds an instrument in his hand worthy of the Ole Bull of native fiddlers.[6]

1 William Sidney Mount, Letter to William Schaus, 3 Mar. 1850, ms, The New-York Historical Society, New York, New York. Printed courtesy of The New-York Historical Society.
2 William Schaus, Letter to William Sidney Mount, 7 Mar. 1850, ms, The Museums at Stony Brook.
3 Mount, autobiographical notes, Jan. 1854, 12.
4 Karen M. Adams, "The Black Image in the Paintings of William Sidney Mount," *The American Art Journal*, 7, no. 2 (1975), 54.
5 Adams, 54–55.
6 "Setauket Scrapbook," 34. The Ole Bull to whom the critic referred was a renowned Norwegian violinist who thrilled American audiences on five tours of the United States he made between 1843 and 1879.

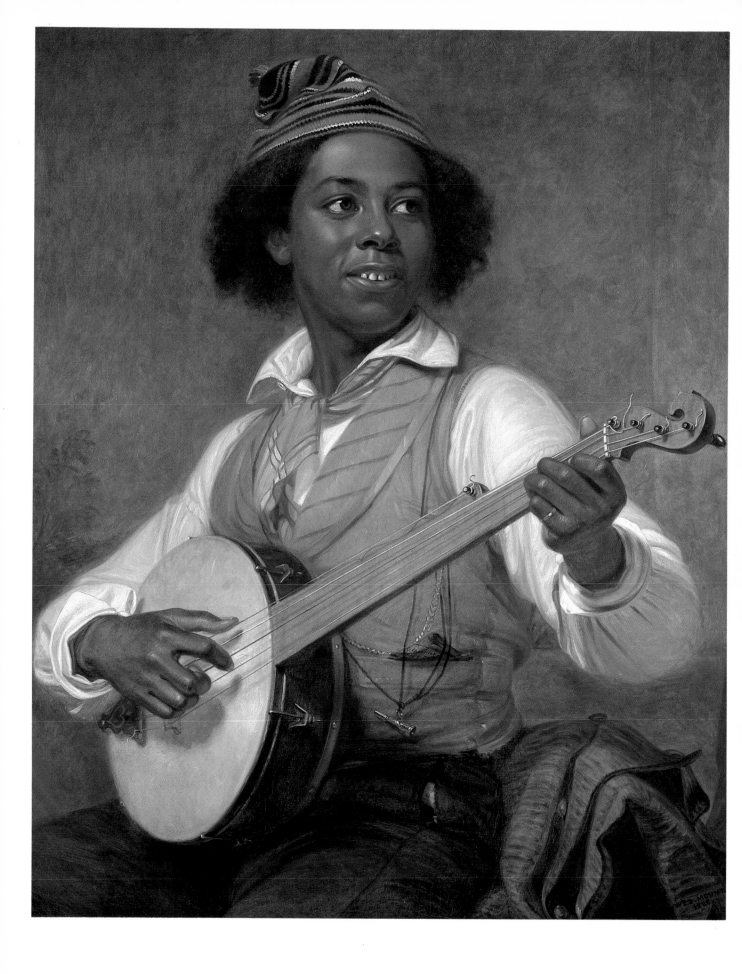

The Banjo Player 1856
Oil on canvas
91.5 × 73.7 (36 × 29)
Inscription: (lower right) *Wm. S. Mount/
1856*; (on reverse) *The Banjo
Player/1856*
Gift of Mr. and Mrs. Ward Melville, 1955

T*he Banjo Player* was one of the last of Mount's paintings to be commissioned by William Schaus for the firm of Goupil & Co. In September, 1852, Schaus wrote to the artist suggesting subjects—"negro playing the Banjo & singing" and "negro playing with bones"—that would be appropriate to enlarge for the Goupil series that already included *Just in Tune*, *Right and Left* and *The Lucky Throw* (a painting whose present location is unknown).[1] With the exception of *The Lucky Throw*, the paintings would all include instruments usually associated with minstrel shows. In comparison to the caricatures on broadsides and other advertisements for nineteenth century minstrel shows, however, Mount's "fancy pictures" of black musicians are quite natural.

As when he had commissioned *Right and Left*, Schaus was still greatly interested in securing the right to produce prints after the two paintings he had suggested to Mount. In 1854 Mount wrote in his journal:

> Two pictures for Wm. Schaus Esqr One a Banjo player, and the other a Bone player. . . . Mr Schaus. has offered to give me two hundred dollars a piece for the above pictures . . . and says—If I should dispose of them to any one else at two hundred dollars each or more, with a priviledge to have them engraved, he will also give me fifty dollars extra. . . .[2]

Mount had little trouble finding a patron to purchase *The Banjo Player*. In 1858, having sold the rights to the print (published in 1857) to Schaus, the artist sold the painting to Charles Leupp for $200.00.[3] Leupp added the canvas to his collection, which already included the *Dance of the Haymakers* and *The Power of Music*. Following Leupp's untimely death in 1859, the painting was sold to Sidney Mason for $260.00.[4]

In a May 1858 entry in his diary Mount reported, "I painted the Banjo player in eight days (16 sittings), two sittings a day."[5] Edward Buffet tentatively identified the subject for this painting as George Freeman:

> He was bound out to R.N.Mount's father-in-law, John Brewster, in whose home . . . William Mount was a frequent visitor. Mr. John B. Mount well remembers that his Uncle William arranged with his grandfather to let George go to Stony Brook a certain number of times to sit for the picture.[6]

Mount completed *The Bone Player* in the same year (in fourteen sittings), and it was sent to Paris with *The Banjo Player* to be published by Schaus.[7] Shortly before Mount sent the canvases to Paris, a critic reviewed them in the July 1, 1856 edition of the New York *Herald*:

> We were yesterday favored with an inspection of the banjo player by W.S.

Mount, intended as a companion to the bones player. . . . In both pictures the artist has chosen the negro in his happiest moments—when, under the influence of musical inspiration, he gives way to all the joyousness and *abandon* of his sensual nature. . . . Both paintings are to be sent to Paris to be engraved. . . . They are just the class of pictures which are likely to attain an extensive popularity.[8]

Today *The Banjo Player* is one of Mount's best-known works. The life-size image of a black musician projects a spirit of talent, warmth and irrepressible vitality. In this figure Mount achieves a monumentality he did not attain in the figure of the dapper fiddler in *Right and Left*. The rich colors of this painting enhance the liveliness of its composition. Mount's talent for capturing fine detail shows here in the printed tobacco pouch stuffed in the young man's vest pocket, in the brightly striped cap and in the glistening gold watch chain.

1 William Schaus, Letter to William Sidney Mount, Sep. 1852, ms, The Museums at Stony Brook.
2 Mount, Diary/Journal 1848–1857, 135.
3 Mount, "Catalogue of portraits and pictures . . .," 28.
4 James T. Callow, "American Art in the Collection of Charles M. Leupp," *Antiques*, 188 (1980), 1006.
5 Mount, Diary/Journal 1857–1868, n. pag.
6 Buffet, Chapter XXXV, *Port Jefferson Times*.
7 Mount, Diary/Journal 1857–1868, n. pag.
8 "Setauket Scrapbook," 43.

Crane Neck Across the Marsh n.d.
Oil on panel
32.5 × 43.3 (12⅞ × 17)
Gift of Mr. and Mrs. Carl Heyser, Jr., 1961

It is believed that William Sidney Mount painted *Crane Neck Across the Marsh* in approximately 1851. It represents his marked departure from the genre style generally associated with his name. This small panel painting demonstrates Mount's ability to create a scene from tonal gradations and broad brushstrokes as well as the delicate slashes of color already evident in the grass of *Farmers Nooning*. In comparison with many of his commissioned portraits and genre scenes, Mount's landscapes are relatively informal works. This landscape seems to be primarily a study of the interaction of colors, in which the tiny figures on the beach in the upper right and the sailboat and sea birds in the upper left assume only secondary importance. *Crane Neck Across the Marsh* epitomizes Mount's statement that "pictures may be made up of a balance of harmonic arrangements of tones."[1]

Mount bathes this scene at Crane Neck Point on the north shore of Long Island in a soft blonde light. He uses subtle colors, cool light and a horizontal expanse of sand to evoke a sense of quietude. These artistic devices are often closely associated with luminism, an American landscape painting movement that thrived in the years between 1855 and 1875, and drew from such sources as traditional marine painting (in its earliest phases) and English painter J.M.W. Turner's evocative atmospheric effects (in his later phase).[2]

1 William Sidney Mount as quoted in Sheldon Reich, "A Stylistic Analysis of the Works of William Sidney Mount, 1807–1868: An American Genre Painter," M.A.T. New York University Institute of Fine Arts 1957, 75.
2 Theodore E. Stebbins, Jr., "Luminism in Context: A New View," in John Wilmerding et al, *American Light: The Luminist Movement, 1850–1875*, Exh. Cat. (Washington, D.C.: National Gallery of Art, 1980), 211.

The Mount House Kitchen n.d.
Pencil on paper
12.3 × 14.7 (4¹³/₁₆ × 5¾)
Gift of Caroline Miller, 1960

In *The Mount House* William Sidney Mount paints his own home in Stony Brook. This small painting documents the mid-nineteenth century appearance of the family home in which the artist lived intermittently following his father's death in 1814. In this view Mount shows the main facade and the west end of the building whose earliest section is believed to have been built in the first quarter of the eighteenth century. When Julia Hawkins Mount died in 1841, she bequeathed the house to her four sons: although Robert's family never lived there, William (a bachelor) did, as did his brothers Henry and Shepard and their families.[1]

This painting clearly shows the improvement William made to his attic studio. The skylight he added in July, 1850 is visible on the right side of the roof. At times the crowded living arrangements in the house strained the nerves of all of its inhabitants. On November 8, 1850 William wrote in his diary:

> My paint room at this time is in a garret on my own property—The first & second stories is occupied by my Brother and his family—They invited me to place a sky light in the garret and now they say they have not room enough—and now my ingenious Sister-in-law—Mrs S.A. Mount, says, she intends to place a bed for her children at the foot of the stairs leading to my Studio. Undoubtedly to cramp my goings in and goings out.[2]

In spite of such minor family tension, the Hawkins-Mount House remained the artist's primary residence until his death in 1868.[3]

In this painting of his home, Mount demonstrates both his tightly controlled brushwork and his looser, more painterly brushwork. The detail with which he describes the exterior of the house contrasts with the soft texture with which he graces the trees that cover the property. The golden tone of the painting and Mount's inclusion of a male figure admiring the house suggest the warm regard the artist had for his home. It is interesting to note that his brother Shepard shared William's fondness for the house which he also painted, although from a slightly different vantage point. Henry's daughter Evelina painted a copy of her uncle William's painting of the house to which she added a female figure (supposedly herself).

Mount documented the interior of this house with the same precision with which he rendered its exterior. His undated pencil sketch of the *Mount House Kitchen* (illustrated here) demonstrates his conscientious attention to detail. The formal, controlled lines with which he draws the candlesticks, the chairs and the table resemble the careful lines with which he drew portraits of members of his family. The detail which Mount lavished on his works of both the exterior and the interior of the Hawkins-Mount House have made it one of the best visually documented homes of its period in the United States.

1 Studenroth, 13.
2 Mount, Diary/Journal 1848–1857, 91.
3 Studenroth, 15.

The Mount House 1854
Oil on canvas
20.3 × 25.6 (8 × 10)
Inscription: (lower right) *Wm. S. Mount*
 Oct. 20ᵗʰ 1854
Bequest of Ward Melville, 1977

The Mill at Stony Brook n.d.
Oil on panel
19.7 × 16.4 (7¾ × 10⅜)
Inscription: (lower right) *Wm. S. Mount*
Bequest of Ward Melville, 1977

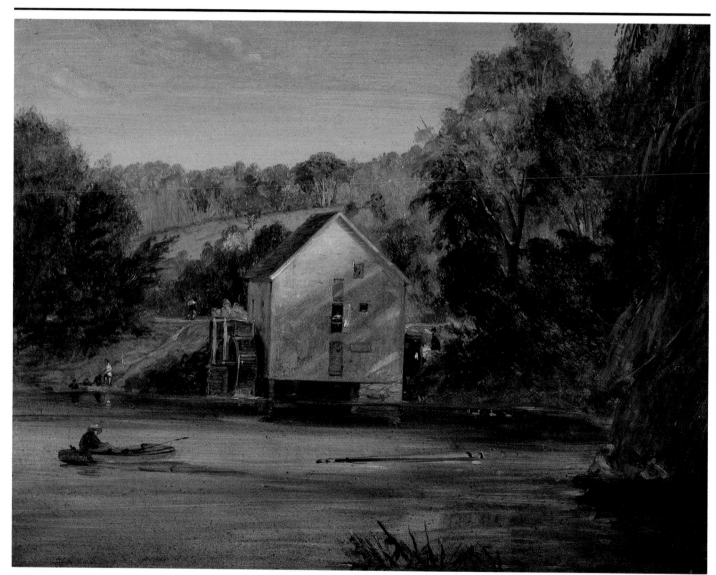

William Sidney Mount's undated panel painting, *The Mill at Stony Brook* (c. 1850), shows that the artist documented his community's buildings with the same accuracy with which he painted scenes of his family's homestead. The mill in this painting was built in 1751 and was the second grist mill to have been erected on the Stony Brook. The first mill had been built by Adam Smith in 1699 on a site approximately five hundred feet southeast of the present site. Smith's mill was reportedly destroyed by a flood. Mount's painting documents the appearance of the second mill prior to an early twentieth century addition to it. The mill (including the addition) still stands on the bank of the Stony Brook.

The Mill at Stony Brook shows not only the grist mill, but also Stony Brook residents' activities on their village waterway. This small panel, filled with tiny figures absorbed in their aquatic pursuits, gives the viewer a sense of calm that recalls waterbugs skating on a quiet pond. Mount uses quick, decisive brushstrokes to describe the figures and the foliage, in contrast to the more precise brushstrokes he uses to delineate the architectural features of the mill. Mount demonstrates his continuing concern for simulating atmospheric effects by painting deep shadows cast on the mill, and clouds drifting across the pink/purple sky.

This painting seems to have been one which was found in Mount's studio after his death in 1868. A painting entitled *Stony Brook Mill Dam* was listed as an item in Mount's 1871 estate sale in New York City. It was priced at $60.00 but, according to the sale records, was not sold at that time.[1]

1 Administrators' Account of William Sidney Mount's estate, schedule B, 19 Aug. 1874, ms, The Museums at Stony Brook.

Spring Bouquet 1847
Oil on oiled paper
17.0 × 15.3 (6⅝ × 6⅛)
Inscription: (lower right) *W.S.M. 1847*
Bequest of Ward Melville, 1977

Spring Bouquet illustrates a seldom-shown aspect of Mount's artistic repertoire—his still life painting. According to the National Academy of Design, still lifes—artistic renderings of such inanimate objects as fruits, flowers and dead game—occupied an inferior position in the hierarchy of appropriate artistic subjects. In the first half of the nineteenth century American still life artists painted arrangements of fruit and, less frequently, vegetables. By 1840 they began to paint flowers as well.[1]

Mount's *Spring Bouquet* is unusual in that it illustrates a bouquet of flowers so casually assembled that they appear to have just been picked. The painting betrays none of the conscious formality of some of the more usual nineteenth century still lifes in which exceptional flowers are arranged in beautiful containers on equally beautiful tables. Both the medium (oil on oiled paper) and the size (6⅝″ × 6⅛″) of this work suggest that Mount may have undertaken it as a creative exercise. Whatever the reason, the artist describes this bouquet of daisies, black-eyed susans and roses with such vivid colors and such lively brushstrokes that they appear to be entirely natural. It is interesting to note that Mount included part of a field of delicately painted black-eyed susans and daisies in one of his later genre works *Farmer Whetting His Scythe* (1848, The Museums at Stony Brook). He was an artist who firmly believed in the truthful portrayal of nature, especially in its detail.

Mount was not the only artist in his family who painted still lifes. His brother Henry, a sign and ornamental painter, painted still lifes as well. It has been suggested that Henry's predilection for images of fish and freshly butchered meat resulted from his practice of painting advertisements that would appeal to fishmongers and butchers.[2] His brother Shepard was noted for his still life paintings. Mount's niece Evelina (Henry's daughter) was an amateur painter who painted flowers perhaps as much because of her uncles' influence and late Victorian taste as her own personal preference. Despite the attraction still life painting held for other members of his family, it held no such attraction for William. On May 29, 1863 he wrote in his journal:

As regards spending time painting apple blossoms & lilacs &c—they are always the same thing over & over—but men & animals are not always so—Man & his dress is ever changing—[3]

1 William H. Gerdts, *Painters of the Humble Truth: Masterpieces of American Still Life, 1801–1939*, Exh. Cat. (Columbia, Mo.: University of Missouri Press, 1981), 20–22.
2 Gerdts, 71.
3 Mount, Diary/Journal 1857–1868, n. pag.

Catching Crabs 1865
Oil on canvas
45.7 × 61.9 (18 × 24⅜)
Inscription: (lower right) *Wm. S. Mount
1865*; (on reverse) *Catching Crabs
W.S.M.*
Gift of Mr. and Mrs. Ward Melville, 1958

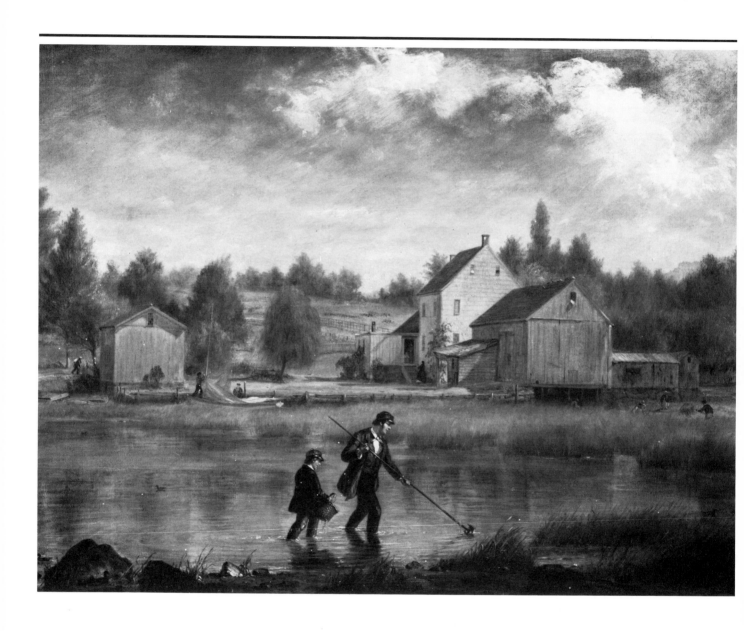

atching Crabs is an example of the genre work William Sidney Mount produced in the last years of his career. In his later years Mount's deteriorating health decreased his productivity considerably. On January 29, 1865, just a few months before he completed *Catching Crabs*, he wrote in his journal:

> *I must scold myself*—urge on dash away some new figure piece—Work 4 or 5 hours a day—have confidence and ask God to assist me—Pictures will "cover the land as the sea covers the deep—" Ideas are to be found in everything if the Poet, sculpter & painter can pick them out—[1]

Mount's age and failing health may have decreased his productivity, but they did not diminish his acute interest in the technical aspects of his work. On March 19, 1865 he wrote this careful description of his treatment of the canvas for *Catching Crabs*:

> Glazed over the lower part of the "Catching Crabs" with madder lake & raw sienna—[?]—oil (bleached) & Demar together, added a little boild oil—glazed the sky with madder lake alone—rubbed all in with the palm of my hand—
>
> The same treatment with muzzle down and touched in some of the clouds & foliage in the glazing.[2]

The subject of *Catching Crabs*, explained by its title, testifies to Mount's lifelong interest in the everyday activities of life on the north shore of Long Island. The painting illustrates a method of crabbing with which many nineteenth century Stony Brook inhabitants were undoubtedly familiar. Edward Buffet included this commentary (apparently originally transcribed by Mount) in his 1923–1924 serialized biography of the artist:

> This Style of taking crabs is true to nature. The fisherman at low tide (without a boat) wades into the water during a calm and spears the crabs; a boy holds the basket; in a short time a mess of crabs can be obtained; a crab net can be substituted for the spear. . . . The artist in choosing the spear gives a better opportunity for showing the crab.[3]

Mount had painted a similar scene in *Eel Spearing at Setauket* (1845, New York State Historical Association, Cooperstown). The figures in *Catching Crabs* lack the tension of stance and expression that dramatize the figures in the earlier painting.

Mount accorded somewhat less importance to detail in his later works. Although the artist intended the focus of this painting to be the pair of figures catching crabs, the viewer's eye is distracted by the men and women at work in the central portion of the composition, and the dramatic clouds in the upper right portion of the composition. In this work the artist describes the trees and the marsh grasses with brushwork that is highly regularized, unlike earlier works (*Farmers Nooning* for example) in which he described each blade of grass in crisp detail.

Catching Crabs was one of four paintings Mount sold to Charles B. Wood of New York City in 1865. He sold this one for $250.00.[4] Mount never lost his ability to secure patrons for his work, even in the later years of his career. In 1858 Wood, an enthusiastic patron, had offered to pay Mount's room and board in the city in exchange for half of the paintings he executed during his stay.[5] Although Mount stayed at Wood's house for ten weeks in the spring of 1859, the artist seems never to have taken advantage of Wood's offer of room and board. Wood's enthusiasm for Mount's work never wavered though, and during the artist's visit to his house in 1859 he made him another offer. Mount made careful note of it: "Mr. Wood said, that if I desired to study landscape this summer from nature that he would furnish all the money—"[6] But he did not accept it. The other Mount paintings in Wood's collection were *The Tease* and *Loitering by the Way* (present locations unknown).

1 Mount, Diary/Journal 1857–1868, n. pag.
2 Mount, Diary/Journal 1857–1868, n. pag.
3 Buffet, Chapter LI, *Port Jefferson Times*.
4 Mount, "Catalogue of portraits and pictures . . . ," 38.
5 Mount, Diary/Journal 1857–1868, n. pag.
6 Mount, Diary/Journal 1857–1868, n. pag.

Catching the Tune 1866
Oil on canvas
55.4 × 67.7 (21⅞ × 26¾)
Inscription: (lower right) *Wm. S. Mount*
Museums Collection

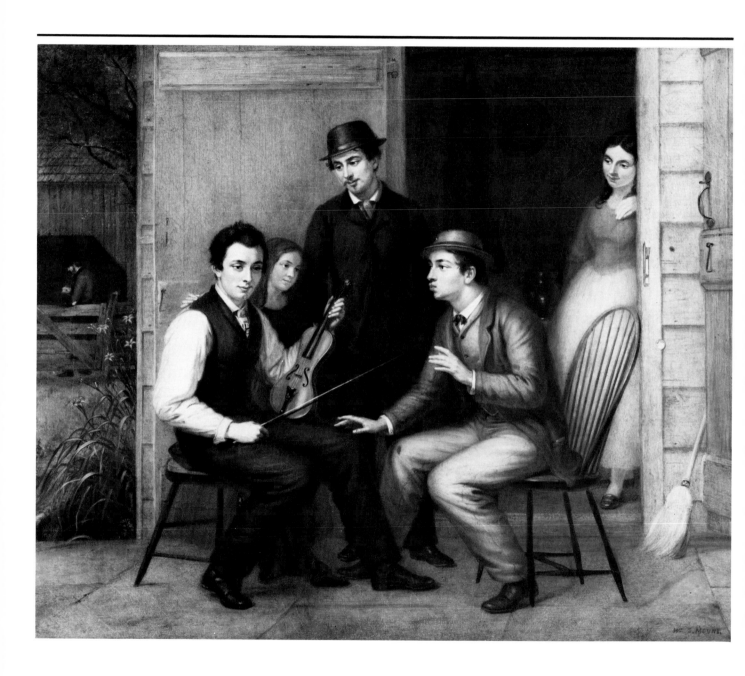

Cradle of Harmony 1857 (patent 1852)
Thomas Seabury, maker; William Sidney
 Mount, designer
Spruce and maple
62.0 × 20.5 (24½ × 8)
Inscription: (back, top) *No. 1./Invented by/*
 Wm. S. Mount N.A.
Museums Collection
Photograph by Michael Madigan, MPS/Island Color

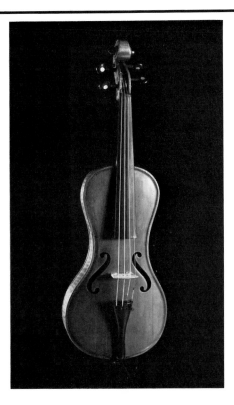 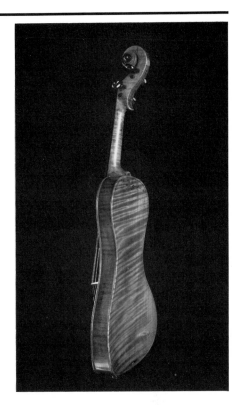

William Sidney Mount's late genre painting, *Catching the Tune*, executed in 1866, was inspired by a letter his brother Robert Nelson Mount had written to him twenty-six years earlier. Though he had trained to be a harness maker, Robert turned his talent to music. (All three of his brothers chose to pursue careers in art.) Robert became an itinerant dancing master, and when he was traveling through Georgia in 1840 he wrote to his brother William:

> I saw recently a scene which I think will make a good picture.—It was two musical characters.—One was whistling a tune, and the other was sitting in a listening attitude with violin in hand ready to commence playing when his 'crony' had finished his part. The subject no doubt is a hacknied one but I do not believe any one has handled it as you can.[1]

William added his brother's suggestion to a list of possible painting subjects he compiled in 1846, but he did not use it until twenty years later. On July 10, 1866, Mount wrote in his journal: "Commenced a picture on canvass, 22 × 27. Catching a tune, 'Possum up a gum tree' Three figures—."[2] The tune Mount mentioned was not among those found in his extensive music collection, but it is believed to be a variant of "Possum up a Gum Stump."[3]

The violin the musician in *Catching the Tune* holds is unique. Mount patented this instrument, which he called the "hollow-back" violin or the "Cradle of Harmony," in 1852. It was quite unlike conventional violins. Mount designed his fiddle to have a guitar-like shape, a concave rather than a convex back and reversed f-holes. As early as 1850 Mount began to develop his design for a modified violin to meet the needs of fiddlers (particularly those who performed in rural areas), who entertained without accompaniment and who needed an instrument that could produce a greater volume than conventional violins could produce.[4] It is believed that James H. Ward constructed the first "hollow-back" violin. James A. Whitehorne and Thomas Seabury (who made the instrument Mount owned) produced later versions of it. Mount was not able to arrange for the large-scale production and marketing of his instrument, but he

was able to arrange for the exhibition of its prototype in the 1853 Exhibition of the Industry of All Nations at the Crystal Palace in New York City.[5]

Catching the Tune shows the same absence of precisely defined forms as does *Catching Crabs*. In 1871 *Catching the Tune* met with the favorable criticism that was given to Mount's work shortly after his death:

> The three principle figures are admirably well painted. One can almost hear the notes issuing from the whistler's lips, and the art of listening has never been better illustrated than by the figure of the violinist.[6]

Nonetheless there is a great difference between the figures in *Catching the Tune* and those in such earlier works as *Dancing on the Barn Floor* and *Dance of the Haymakers*. Unlike their earlier counterparts, the figures in the later painting barely interact: their heavy-lidded eyes stare into space and their bodies suggest little real motion. Mount arranges them in a compositional formula reminiscent of his earlier works—

the placement of the hat and coat on the back wall is similar to that in *The Sportsman's Last Visit*—but he defines the receding space much less clearly. The woman's skirt that is an unvaried mass of color and the broom's bristles that appear to be part of the floor on which they stand clearly indicate that the artist's eye is failing. *Catching the Tune* appears to be more the product of the artist's nostalgia than of the keen observation of life and nature for which he is so well known.

Catching the Tune was one of the paintings found in Mount's studio after his death in 1868. It was sold at his estate sale to an unidentified buyer for $300.00.[7]

1 Buffet, Chapter XIX, *Port Jefferson Times.*
2 Mount, Diary/Journal 1857–1868, n. pag.
3 Buechner, "Music and Dance in the Paintings of William Sidney Mount," 3–4.
4 Buechner, "Music and Dance in the Paintings of William Sidney Mount," 4–5.
5 Alan C. Buechner, "William Sidney Mount's 'Cradle of Harmony': A Unique 19th Century American Violin," *Journal* of the Violin Society of America, 3, No. 2 (1977), 50–68.
6 New York *Herald*, 10 Apr. 1871, as quoted in Cowdrey and Williams, 32–33.
7 Administrators' Account of Mount's estate, schedule B.

Costume Sketch n.d.
Pencil and watercolor on paper
12.3 × 10.2 (4⅞ × 4)
Inscription: (in image on skirt) *Green*
Bequest of Ward Melville, 1977

This untitled costume sketch (c. 1832) is a rare example of a William Sidney Mount watercolor. According to the artist's autobiographical notes, he was first introduced to this delicate medium in 1819:

> A Lady accomplished in water color painting, as taught at that time, gave my Sister, lessons in painting, and also taught her embroidery . . . You could have seen me at that time a farmer Boy . . . watching with deep interest the manner in which the beautiful Teacher was mixing her colors, and directing her young pupil.[1]

Years after Mount first encountered watercolor painting at his sister's lessons he studied art at the National Academy of Design (1826–1827). There the primary emphasis of instruction concentrated on sketching and copying casts of classical sculptures. This watercolor costume sketch suggests that when Mount approached this new medium he forsook his academic training in sketching tonal gradations and opted for the same linear outlines with which he had executed such early paintings as *Christ Raising the Daughter of Jairus.*

The figure in this small watercolor appears to be either a member of an acting troupe performing at the Bowery Theatre in New York City, or a member of that theater's audience. At the time he executed this work Mount lived in New York City and sketched a number of theatrical subjects. The spontaneity with which the artist renders this petite figure adds to her vivacity. The artist emphasizes her liveliness with spots of color on her cheeks and her skirt. Mount's quick impression of this figure, which he renders in a relatively difficult and demanding medium, further attests to his extraordinary power of observation.

1 Mount, autobiographical notes, Jan. 1854, 1.

The Volunteer Fireman n.d.
Watercolor on paper
10.0 × 11.2 (4 × 4⁷⁄₁₆)
Bequest of Ward Melville, 1977

*T*he Volunteer Fireman (c. 1835) is another example of a Mount watercolor. Its composition is far more intricate than that of the *Costume Sketch*, as it depicts an interior with four figures. The interior is that of a dining room or parlor in which a pair of portraits hangs above a sideboard. A young child gleefully points to a fire just visible in the distance as her father calmly prepares to attend to his public duties. In this watercolor the artist documents both a nineteenth century household's interior and a nineteenth century early fire fighter's uniform.

By covering the interior pictured here in a thin gray wash, Mount draws attention to the four figures and the view through the window. Mount uses the color of his paper to highlight the sky and the costumes worn by the small child and the man. The artist balances the father's reach for his trumpet with the older child's gesture. As in the *Costume Sketch*, the artist clearly outlines his figures and uses color to emphasize such details as the mother's dress and the tea service. Although Mount does use shading to further define other areas of this painting, the strength of this diminutive composition lies in its lines and its figures' gestures.

Portrait of Julia Ann Hawkins Mount
1841
Pencil on paper
28.0 × 20.3 (11 × 8)
Inscription: (bottom center) *A Sketch of his Mother by / Wm. S. Mount / June 1841*
Gift of Edith Douglass and Mrs. Mary D. Rackliffe, 1971

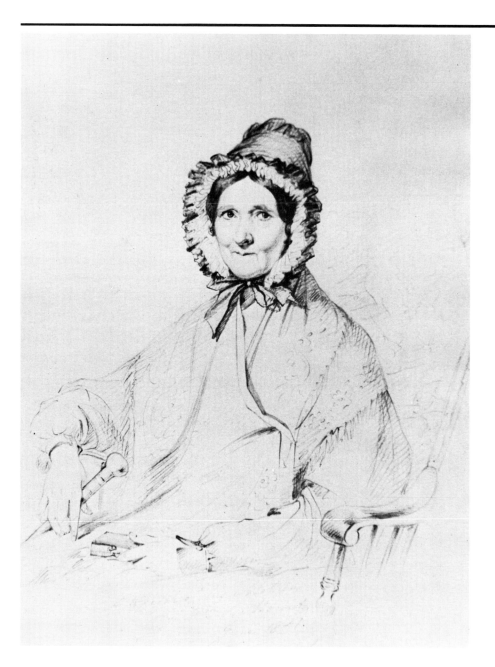

William Sidney Mount's *Portrait of Julia Ann Hawkins Mount* attests to his accomplished draftsmanship. Even as early as 1828, Mount had astounded Samuel F. B. Morse with his command of line. Mount had two quite distinct drawing styles; a very crisp figural style that this sensitive portrait of his mother exemplifies, and a sketch style marked by quick, flowing lines. In this drawing the artist uses a series of intersecting lines rather than tonal gradation to create the shadows in his mother's face and her bonnet. He renders such secondary features as her torso and the chair in a few decisive lines that clearly define the forms in a kind of visual shorthand.

The artist recorded the date he drew this sketch as June 1841. His mother died five months later. Mount showed his deep affection for his mother in a warmly eulogistic remark to his close friend, Charles Lanman: "I never shall forget the warm pressure of my mother's hand when she was dying. It was the last pressure of approbation."[1]

It is interesting to note that in the drawing his mother clutches what appears to be a case that contains either a miniature painting or a daguerreotype. If it were a daguerreotype, this sketch would indicate that photographs were used as keepsakes quite soon after the introduction of the photographic process to the United States.

1 Lanman, 178.

Beached Sloop, Conscience Bay n.d.
Pencil on paper
26.7 × 34.3 (10½ × 13½)
Inscription: (lower right) *Wm. S. M.*
Bequest of Ward Melville, 1977

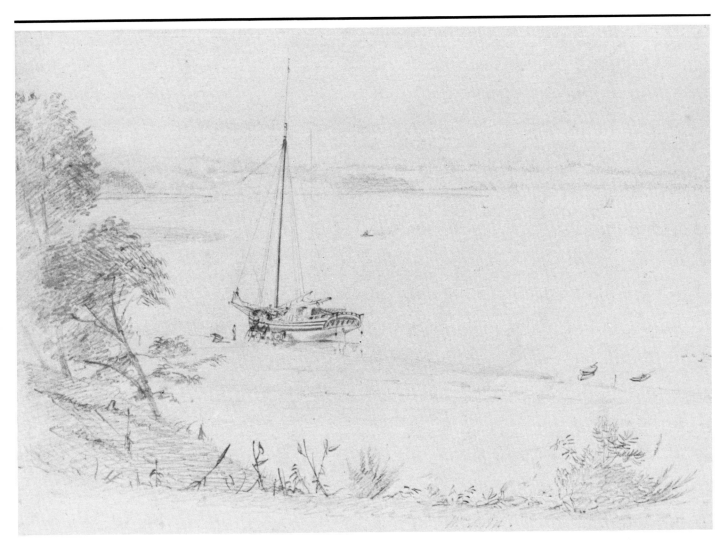

In this undated sketch, *Beached Sloop, Conscience Bay*, Mount meticulously records a gaff-rigged vessel awaiting high tide. W. Alfred Jones's remark that "A great artist will make more of an ordinary scene than the inferior genius will be able to create out of the noblest materials" seems applicable to this sketch.[1] This "ordinary scene" from Conscience Bay provides yet one more example of the variety of drawing and painting subjects Mount found on the north shore of Long Island.

This scene in the bay north of Stony Brook appears to document a method of beaching a vessel for the purpose of scraping its hull or making repairs below the water line. The ship would have been careened, or rocked to one side, during low tide to facilitate the task of cleaning its hull. As this drawing indicates, the large vessel would have been secured to a point on the shoreline by a rope attached to its rigging, high on the mast; the placement of the rope would have helped to right the sloop when high tide came in.

The focus of this composition is the sloop. Mount draws the sloop with the same crisp lines with which he drew the Mount House kitchen. The artist chose to include even such minute details as the davits on

the sloop's stern from which a lifeboat would have been hung. The precise lines with which he delineates the sloop's form contrast with the softer lines with which he renders the trees and the foliage in the foreground. Mount made a practice of combining crisp and soft lines to differentiate between objects of primary and secondary importance, respectively, both in his drawings, and in some of his paintings (of which *The* Herald *in the Country* is an example).

1 W. Alfred Jones, 122.

Boy at the Well Sweep n.d.
Pencil on paper
20.0 × 24.8 (7⅞ × 9¾)
Inscription: (bottom center) *Wm. S. Mount*
Bequest of Ward Melville, 1977

Boy at the Well Sweep is another undated sketch in which Mount depicts a scene of everyday life. The artist was clearly an avid observer of his fellow man. One recent writer's opinion is that:

He was a kind of dispassionate chronicler of the outward actions of men, and took meticulous notes to record the minutiae not of the eccentric or unusual, but of the habitual, which he de-

scribed point by point, as though he were seeing something extraordinary for the first time.[1]

Here the artist portrays a young boy who fetches water from a well with a degree of concentration that elevates the scene above the commonplace.

Mount again combines crisp, impressionistic and sweeping lines to define his forms. The slashing lines with which he describes the rocks and the flowers contrast

with the more precise lines with which he defines the boy, the well and the house. The artist includes such details as the wood beams in the ceiling that are just inside the house. Mount cleverly uses the device of the crooked axe handle to lead the viewer's eye to the central focus of the composition—a boy intently performing his daily task.

1 Abraham A. Davidson, "William S. Mount: The Mysterious Stranger," *Art News*, 68, No. 1 (1969); 36.

The Setauket Military Band n.d.
Pencil on paper
26.7 × 34.3 (10½ × 13½)
Bequest of Ward Melville, 1977

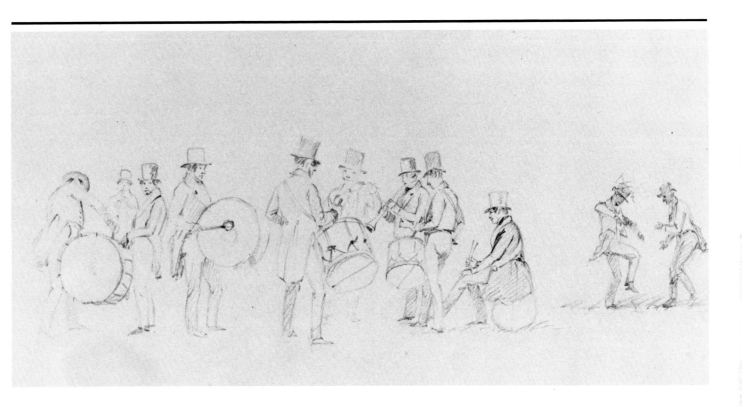

This comparatively large sketch, entitled *The Setauket Military Band*, has been tentatively dated c. 1840. It is one of a series of military sketches William Sidney Mount produced. It is a lively drawing that captures the artist's momentary impression of the band members and two black onlookers. The band appears to have been practicing: the distrustful expression assumed by the gentleman who assists the drummer (on the left) suggests that the artist has caught him off his guard. The man who sits on the drum listens intently to his fellow musicians, who strike a casual pose. Mount captures this top-hatted but less than formal group in a series of quick, free-flowing lines. The artist masterfully uses a few short, broad slashes to describe the two dancing black figures' hands. The unfinished appearance of the face of the central figure who plays a flute (or a fife) indicates that the artist intended this to be a working sketch, not a finished image.

Unfortunately Mount did not identify the event that inspired this drawing. The men's garments lack the military adornments in which a modern viewer would expect to see such a group arrayed. The band in the drawing may well have been performing at an annual federal militia parade. According to a modern Long Island historian, such parades were:

> of marginal popularity with the majority of the population. While the fine system forced many a reluctant soldier to appear at parades and stand in ranks, it was often less trouble, for example, to pay a fine than purchase a musket. . . . Annual parades lacked the military atmosphere one might expect.

The scene more closely resembled a convention: news of the harvest was exchanged, old acquaintances were renewed and new ones made, and tradesmen vended their wares.[1]

The two black dancers' lightheartedness contrasts sharply with the serious expressions several of the band members assume. Unlike others of Mount's works featuring black men (several of which are mentioned above), this drawing shows black men in an attitude that may appear to the modern viewer to be quite close to a nineteenth century stereotype.

1 David C. Clemens, "The Suffolk County Militia from the Revolutionary War to 1868," in *Mustering and Parading: Two Hundred Years of Militia on Long Island, 1654–1868*, Exh. Cat. (Huntington Historical Society, 1982), 25, 28.

Headstrongs—First thoughts of California and the Gold diggings—March 26, 1849 (upper left)
Pencil and ink on paper
14.0 × 18.0 (5½ × 7 1/16)
Inscription (bottom): *Headstrongs—First thoughts of California and the Gold diggings—*; (top, right) *March 26th 1849*
Museums Collection

Headstrongs Uncle tries to discourage him from going to California—March 26, 1849 (upper right)
Pencil and ink on paper
14.1 × 17.8 (5 9/16 × 7)
Inscription (bottom): *Headstrongs Uncle tries to discourage him from going to California—*; (top, left) *March 26—1849*
Museums Collection

Headstrong has a Dream—
March 26, 1849 (middle left)
Pencil and ink on paper
14.0 × 18.0 (5½ × 7 1/16)
Inscription (bottom): *Headstrong has a Dream*; (top, right) *March 26th—49*
Museums Collection

**Headstrong prefers the Overland route
to the Gold diggings—on he goes—**
March 26, 1849 (middle right)
Pencil and ink on paper
14.0 × 18.2 (5½ × 7³⁄₁₆)
Inscription (bottom): *Headstrong prefers the
Overland route to the Gold diggings—on
he goes—*; (top, right) *March 26—1849*
Museums Collection

**Headstrong—Sifting Gold in the dry dig-
gings—**March 26, 1849 (lower left)
Pencil and ink on paper
14.0 × 18.1 (5½ × 7⅛)
Inscription (bottom): *Headstrong—Sifting
Gold in the dry diggings*; *March 26ᵗʰ
1849—*
Museums Collection

**Headstrong has his Gold stolen from
him while he sleeps—by an** <u>Indian</u> **—**
March 26, 1849 (lower right)
Pencil and ink on paper
14.3 × 18.0 (5⅝ × 7¹⁄₁₆)
Inscription (bottom): *Headstrong has his
Gold stolen from him while he sleeps—by
an* Indian—; (top, right) *March 26—1849*
Museums Collection

This series of six drawings by William Sidney Mount recounts the misadventures of an imaginary young man named "Headstrong," who is infected with "yellow [gold] fever" shortly after the 1848 discovery of gold at Sutter's Mill, California. The drawings demonstrate Mount's disapproval of the mass hysteria that disrupted much of the country when gold was discovered. In his well-known painting of 1850, *California News* (The Museums at Stony Brook, illustrated p. 60), the artist expresses the same sentiments in a more subtle way.

In the first drawing of the series, Headstrong ponders a broadside advertising passage to California on the *Loo Choo* and entertains his "first thoughts of California." It is the same broadside that appears on the wall of the post office in *California News*. In the second drawing "Headstrongs Uncle tries to discourage him from going to California—." This scene takes place on a city street under another broadside promoting passage to California. Headstrong rejects his uncle's good counsel when he has a dream in which the wealth and leisure gold can offer are represented by a pillared mansion, a fine carriage and pleasurable activities—sailing, fishing and hunting. The dream comes to Headstrong as he dozes with a broadside on his lap and a pick and shovel by his chair. The next two scenes show Headstrong pursuing his dream on foot, as he "prefers the Overland route;" and presumably much later, "sifting Gold in the dry diggings." The ultimate result of his youthful folly comes to pass: "Headstrong has his Gold stolen from him while he sleeps—by an *Indian—*."

Mount's serial treatment of these drawings—almost a comic strip—is unique among his known works. Mount's written description of thirty-three scenes in the unhappy romance of "Mr. Dignity," a village schoolmaster, is preserved in The New-York Historical Society, but is not known to have led him to create paintings or drawings of it. Eighteenth century English artist William Hogarth did several series of paintings and engravings—*The Harlot's Progress*, *The Rake's Progress* and *Marriage à la Mode*. Mount's autobiographical notes and his early sheet of heads "drawn from Hogarth" (n.d., The Museums at Stony Brook, illustrated p. 15), indicate that Hogarth's engravings were among the first prints Mount studied. Such sequential statements also appeared in American popular prints of the nineteenth century. Nathaniel Currier's *The Drunkard's Progress* (1846) is often cited as an example of serial images in a single print. Whether or not Mount's sequential treatment of Headstrong's progress toward ruin was influenced by other artists whose work he knew, he used it well to summarize his opinions about those who caught gold fever and rushed to California to assuage it.

Waiting for the Tide 1848
Pencil on paper
23.3 × 14.8 (9⅛ × 5¹³⁄₁₆)
Inscription: (lower right) *Aug. 29, 1848*;
 (bottom) *Waiting for the Tide*
Bequest of Ward Melville, 1977

*W*aiting for the Tide, dated August 29, 1848, documents Mount's impression of a common Long Island pastime—clamming. The young sitter for this nostalgic boyhood scene has not been identified, but may well have been one of the artist's nephews or neighbors. The artist appears to have caught the boy in the midst of a daydream he has fallen into while he waits for the tide to go out. He has temporarily left his clamming gear—a large basket and a hoe—on the sand. Mount renders this sketch with a series of quick, slashing lines, but includes such details as the shells that lie at the boy's feet.

In 1850 Mount recorded in his journal that he had been engaged to paint a scene entitled "Waiting for the tide."[1] That painting (the location of which is unknown) apparently remained in the artist's studio until his death in 1868. The painting's actual size and appearance are unknown, but records show that it was sold at Mount's estate sale in 1871 for the sum of $45.00.[2]

1 William Sidney Mount, Diary/Journal 1846–1850, n. pag., ms, The Museums at Stony Brook.
2 Administrators' Account of Mount's estate, schedule B.

Slaughtering Hogs n.d.
Pencil on paper
31.4 × 42.2 (12⅜ × 18⅝)
Inscription: (bottom right) *Wm. S. Mount*
 Dec. 13th 18[?]
Bequest of Ward Melville, 1977

Mount's drawing, *Slaughtering Hogs*, has been tentatively dated 1860. The artist carefully recorded the date of this sketch as Dec. 13, 18[?] but part of the date has been obliterated (the third numeral appears to be either a 5 or a 6). However, the scene documents a common annual activity for Mount's neighbors.

Nineteenth century Long Island historian Benjamin Thompson acknowledged Mount's talents for art and observation in his 1839 *History of Long Island*:

A constant attention to drawing—a profound study of such specimens of coloring as fell his way, with great devotion to the practice and study of design, has already been rewarded by skill of uncommon grade, and he now occupies, by the unanimous consent, the first rank in the class of humorous and domestic scenes.[1]

Slaughtering Hogs documents a nineteenth century Long Island farm's method of hog slaughter. One of the standing figures on the left holds the mallet with which he has just stunned a hog. Mount draws the scene with great objectivity: he avoids the gruesome detail of the event, and uses only a hint of orange chalk to suggest the blood that has fallen beneath the hanging carcass.

The lines of this drawing are quick and decisive, like the actions of the men slaughtering the hogs. Mount highlights various details of this drawing with dashes of white, yellow and orange chalk, something he rarely did in his other sketches. His use of color for emphasis here recalls his treatment of color in his earlier watercolors.

1 Benjamin F. Thompson, *The History of Long Island from its Discovery and Settlement to the Present Time*, 2nd ed. (New York: Gould, Banks & Co., 1843), II, 528.

Portrait of Midshipman Seabury 1868
Pencil on paper
25.1 × 19.5 (9⅞ × 7¹¹⁄₁₆)
Inscription: (lower center and lower right)
Bequest of Ward Melville, 1977
Mid.ⁿ Seabury./Sketch by Wm.S.Mount./
Sepᴸ 25ᵗʰ 1868

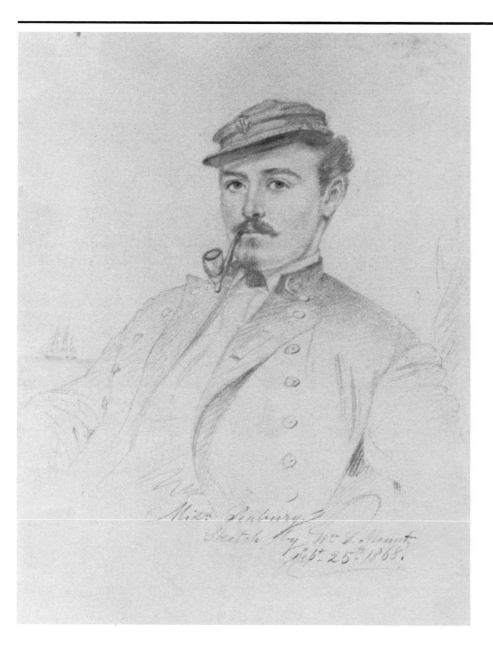

William Sidney Mount's *Portrait of Midshipman Seabury*, dated September 25, 1868, is the artist's last known work. Mount's dapper nineteen-year-old nephew, Samuel Seabury (Ruth Hawkins Mount Seabury's youngest son) is its subject. As he recorded in a journal entry dated September 28, 1868, Mount drew this portrait when his nephew came home on leave from Annapolis:

> = I spent from Sun y 20 to 26, with my sister & family. Midn. Samuel Seabury at home; he draws finely with the pencil. He left for Annapolis M.D. to day, Sept. 28, a fine day.[1]

This fine portrait shows that Mount no longer relies entirely on crisp lines to delineate a portrait image. Unlike his earlier portrait of Julia Ann Hawkins Mount, in which he had used intersecting lines to define facial contours, Mount here uses subtle shading and softened outlines to suggest the contours of his nephew's face. As in his "first likeness," in which he included a flute as an attribute of his own musical avocation, Mount here includes a ship, in the distance, as an attribute of his nephew's vocation.

Though he may have trained as a midshipman, Samuel Seabury enjoyed the unusual privilege of being one of the few young artists to receive informal art instruction from William Sidney Mount. (The Museums collection includes two seascapes young Seabury drew after printed sources.) On October 13, 1862 Mount sent his nephew a letter (illustrated here) filled with illustrations and instructions on painting; where to purchase oiled paper, which colors to include in a palette (with examples of pigments) and how to clean brushes. Mount closed his letter with advice for his nephew that summarized his own lifelong artistic philosophy: "Practice & a good eye makes the painter."[2]

1 Mount, Diary/Journal 1857–1868, n. pag.
2 William Sidney Mount, Letter to Samuel Seabury, 13 Oct. 1862, ms, The Museums at Stony Brook.

94

Letter to Samuel Seabury 1862
Ink and oil on paper
39.2 × 50.3 (15½ × 19⅞)
Museums Collection

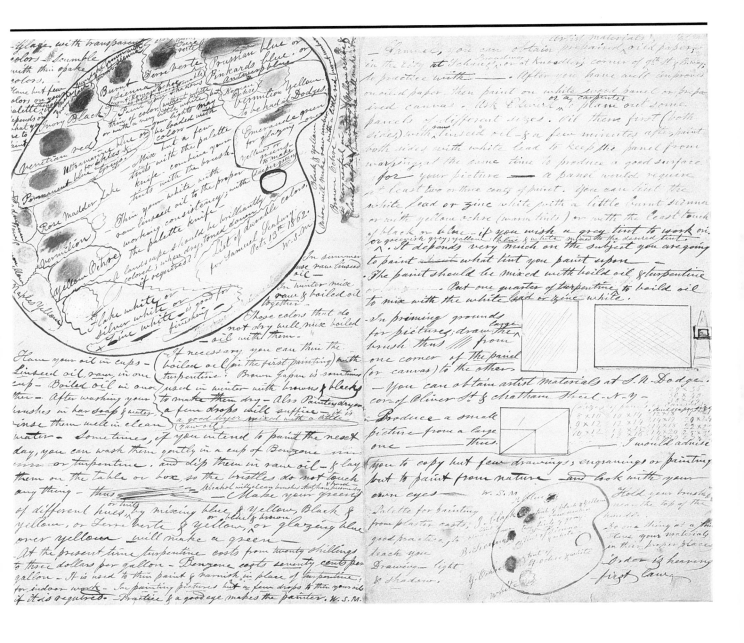

Further Reading

Brown, Milton W. *American Art to 1900*. New York: Harry N. Abrams, Inc., 1977.

Cassedy, David, and Gail Shrott. *William Sidney Mount: Annotated Bibliography and Listings of Archival Holdings of The Museums at Stony Brook*. Stony Brook, N.Y.: The Museums at Stony Brook, 1983.

Cowdrey, [Mary] Bartlett, and Hermann Warner Williams, Jr. *William Sidney Mount, 1807–1868: An American Painter*. New York: Columbia University Press, 1944.

Craven, Wayne. "Luman Reed, Patron: His Collection and Gallery." *The American Art Journal*, 12, No. 2 (1980), 40–59.

Feld, Stuart P. "In the Midst of 'High Vintage'." *The Metropolitan Museum of Art Bulletin*, 25 (1967), 292–307.

Flexner, James Thomas. "Painter to the People." *American Heritage*, 11, No. 5 (1960), 10–23, 91–92.

Frankenstein, Alfred. *Painter of Rural America: William Sidney Mount, 1807–1868*. Exh. Cat. Stony Brook, N.Y.: The Suffolk Museum, 1968.

———. *William Sidney Mount*. New York: Harry N. Abrams, Inc., 1975.

———. Jacket Notes. *The Cradle of Harmony: William Sidney Mount's Violin & His Fiddle Music*. Violinist Gilbert Ross. Folkways Records, FTS 32379, 1976.

Groseclose, Barbara. "Politics and American Genre Painting of the Nineteenth Century." *Antiques*, 120 (1981), 1210–17.

Hills, Patricia. *The Painters' America: Rural and Urban Life, 1810–1910*. Exh. Cat. New York: Praeger Publishers in association with the Whitney Museum of American Art, 1974.

Hoover, Catherine. "The Influence of David Wilkie's Prints on the Genre Paintings of William Sidney Mount." *The American Art Journal*, 13, No. 3 (1981), 4–33.

Keyes, Donald D. "The Sources for William Sidney Mount's Earliest Genre Paintings." *The Art Quarterly*, 32 (1969), 258–68.

———. "William Sidney Mount Reconsidered." Rev. of *William Sidney Mount*, by Alfred Frankenstein. *American Art Review*, 4, No. 2 (1977), 117–28.

Lynes, Russell. *The Art-Makers of Nineteenth-Century America*. New York: Atheneum, 1970.

Novak, Barbara. *American Painting of the Nineteenth Century: Realism, Idealism and the American Experience*. New York: Praeger Publishers, Inc., 1969.